MARY PRATT

MARY PRATT

GOOSE LANE

The Rooms
ARCHIVES · ART GALLERY · MUSEUM
Newfoundland & Labrador
Canada

AGNS

Art Gallery of Nova Scotia

Goose Lane Editions acknowledges the generous support of the Canada Council for the Arts, the Government of Canada through the Canada Book Fund (CBF) and the Government of New Brunswick through the Department of Tourism, Heritage, and Culture.

Goose Lane Editions
500 Beaverbrook Court, Suite 330
Fredericton, New Brunswick
CANADA E3B 5X4
www.gooselane.com

The Rooms Corporation of Newfoundland and Labrador
Provincial Art Gallery Division
9 Bonaventure Avenue
PO Box 1800, Station C
St. John's, Newfoundland
CANADA A1C 5P9
www.therooms.ca

Art Gallery of Nova Scotia
1723 Hollis Street
Halifax, Nova Scotia
CANADA B3J 1V9
www.artgalleryofnovascotia.ca

Published in conjunction with the exhibition *Mary Pratt*, organized by The Rooms, St. John's (May–September 2013) and the Art Gallery of Nova Scotia, Halifax (September 2014–January 2015). Travelling to the Art Gallery of Windsor (September 2013–January 2014), the McMichael Canadian Art Collection, Kleinburg, Ontario (January–April 2014) and the MacKenzie Art Gallery, Regina (May–August 2014).

Edited by Dr. Denis Longchamps and Meg Taylor.
Copy edited by Ruth Gaskill.
Dust jacket and page design by Julie Scriver.
All dimensions of artwork are given in centimetres, height preceeding width.
Printed in Canada.
10 9 8 7 6 5 4 3 2 1

Library and Archives Canada Cataloguing in Publication

Mary Pratt.

Co-published by: The Rooms Corporation of Newfoundland and Labrador, Provincial Art Gallery Division; Art Gallery of Nova Scotia. Companion to the travelling exhibition of works by Mary Pratt that will visit five galleries from 2013-2015.
Issued also in French.
Includes bibliographical references.
ISBN 978-0-86492-911-2

1. Pratt, Mary, 1935- . 2. Pratt, Mary, 1935- —Exhibitions.
I. Pratt, Mary, 1935- II. Art Gallery of Nova Scotia
III. Rooms Provincial Art Gallery (N.L.)

ND249.P76M37 2013 759.11 C2013-900702-4

Contents

Preface

TOM FORAN, Chair, Board of Directors
and DEAN BRINTON, CEO, The Rooms

Although hailing from New Brunswick, Mary Pratt has long been considered a beloved daughter of Newfoundland and Labrador. The extraordinary body of work that Mary has produced over the past decades has helped form the very ethos of this place. The pages that lie ahead capture the profound influence that Mary Pratt's work has had on the identity of Newfoundland and Labrador, Canada and the world of fine art. Her tireless efforts on behalf of the arts deserve special recognition in this catalogue of her life's work.

Over the years, Mary Pratt has championed the arts through numerous volunteer roles, including the Federal Cultural Policy Review Committee, the Board of Directors of the Canada Council for the Arts and serving as co-chair of the committee that guided the creation of The Rooms – the largest cultural institution in Atlantic Canada. Although Mary may question the impact that she has had in many of these roles, the establishment of The Rooms on the skyline of St. John's is an ineluctable symbol of her passion and effectiveness as an advocate for the arts and culture sector. While it has become part of our provincial lore that Newfoundland and Labrador would not have The Rooms without Mary Pratt, those of us who hail from here all agree that Newfoundland and Labrador wouldn't be the same without Mary.

Funding for this touring exhibition and catalogue has been generously provided by the Department of Canadian Heritage, the Province of Newfoundland and Labrador and the Province of Nova Scotia. On behalf of the Board of Directors of The Rooms Corporation, thank you to everyone that has helped make The Rooms the success that it has become over the past eight years. And a special thank you to Mary Pratt for her foresight and determination.

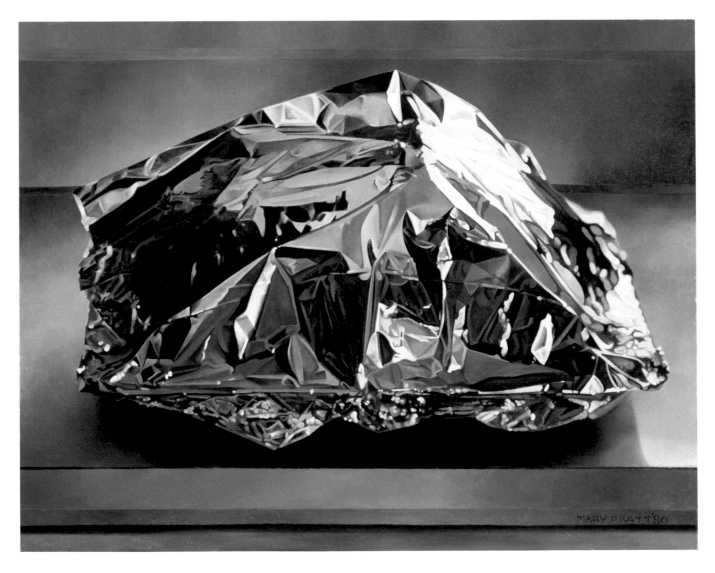

Christmas Turkey, 1980
oil on Masonite
45.7 x 59.7 cm

Then happy I, that love and am beloved,
Where I may not remove nor be removed.
—William Shakespeare, Sonnet XXV

This exhibition weaves together a narrative of the lifetime's work of Mary Pratt. When arranging with the many collectors to borrow artwork for this national touring retrospective, something became endearingly clear: Mary's work has become a part of people's lives and homes in a way that not many artists can claim. People find something of themselves in her art.

To know Mary Pratt is a privilege. This exhibition reflects her commitment, determination, tenacity and resolve. Distilled in a selection of seventy-five works spanning five decades, the exhibition will travel to five venues across Canada. Viewers will have the chance to get to know, and see, why Pratt is considered Canada's most illustrious female painter.

An endeavour of this complexity takes dedication and collaboration. Firstly, I would like to thank Ray Cronin and the Art Gallery of Nova Scotia for working with us on this exhibition. We make great partners and it is fitting that the tour will begin in Newfoundland and end in Nova Scotia. I am pleased to announce that this exhibition will also travel to the Art Gallery of Windsor, the McMichael Canadian Art Collection and the MacKenzie Art Gallery.

This retrospective is made possible through the generosity of all those who have lent work to the exhibition. Thank you for helping bring *Mary Pratt* into being. I would also like to thank Gisella Giacalone of Mira Godard Gallery, Toronto, and Andy Sylvester of Equinox Gallery, Vancouver, for their tremendous help.

Special thanks for the keen efforts of the exhibition curatorial team of Caroline Stone, Sarah Fillmore and Mireille Eagan. Together, they have presented Mary's work in a fresh, contemporary manner. Creative contributors to the exhibition also include Ned Pratt, Mark Bennett, Michel Savard, Catherine Chafe, Charlotte Magnin, Sandy Newton as well as members of the staff at The Rooms and the Art Gallery of Nova Scotia. I would also like to acknowledge Mern O'Brien for her enthusiasm and support; it is greatly appreciated.

In addition, I would like to acknowledge the significant contribution to the publication and exhibition by the distinguished writers — Ray Cronin, Sarah Fillmore, Mireille Eagan, Caroline Stone, Catharine Mastin, Sarah Milroy, Mark Callanan and Lisa Moore. The Rooms is pleased to have been associated with Susanne Alexander, Julie Scriver and the staff of Goose Lane Editions. Thanks to all for their remarkable efforts.

The exhibition and tour of *Mary Pratt* is made possible through the generous support of the Museum Assistance Program of Canadian Heritage and by the continued support of the Province of Newfoundland and Labrador.

Our most heartfelt appreciation and thanks to Mary Pratt for her patience, guidance and, most of all, her creative vision and achievements and for sharing them with all of us.

Foreword

RAY CRONIN, Director and CEO
Art Gallery of Nova Scotia

Mary Pratt, The Rooms and the AGNS have something in common: a shared belief in the absolute necessity of finding new ways to ensure that the arts, which always seem so fragile in this region, are empowered and supported. Mary does that through her own example. She is a remarkable artist who has chosen to make her stand here on the east coast and who, from her redoubt in St. John's, never fails to provide concrete proof that one does not have to toil in obscurity should one also choose to toil in Atlantic Canada. This exhibition provides ample evidence and marvellous examples of her artistic excellence and importance to this country's art history.

On behalf of the Art Gallery of Nova Scotia's board, staff and members, I would like to thank the many lenders to this exhibition, whose generous loans have allowed the retrospective to come to life. Support from the Department of Canadian Heritage through the Museums Assistance Program has been vital to the project, as have been the efforts of this book's publisher, Goose Lane Editions, and the various writers whose texts are found herein. The curators, Mireille Eagan, Sarah Fillmore and Caroline Stone, have much to be proud of in this wonderful exhibition, and I would also like to thank my counterpart Sheila Perry for her diligent work on behalf of this project. Finally, a thank you to Mary, whose patience, generosity, persistence and commitment to her art and vision is an inspiration to us all.

Ray Cronin

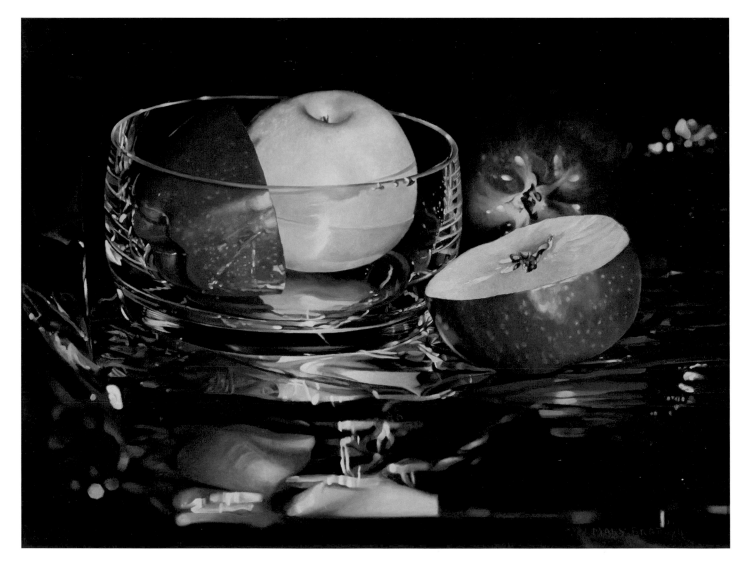

Glassy Apples, 1994
oil on canvas
46.0 x 61.0 cm

A Note from the Curators

MIREILLE EAGAN, SARAH FILLMORE and CAROLINE STONE

History is never straightforward. It is composed of various standpoints and underlying currents. It accumulates, it folds and it pushes. This publication is intended as a companion piece to the touring exhibition *Mary Pratt*. Carrying simply the artist's name without subtitle, both the exhibition and the publication reflect on the conversation of themes that weave through and around Mary's art.

The exhibition will explore these themes in the gallery space, presenting selections from her body of paintings so that the viewer can consider Mary's artistic process, the role of place and personal biography, the passage of time and the very act of looking. The essays found in this publication represent the range of writing that can form a history and are meant to provide a tangential commentary to the exhibition itself. As the reader will notice, the approaches of the authors overlap but are not necessarily the same.

■ ■ ■

Created in a particular time, this publication will exist long after the exhibition is complete. It is our hope that the writings within it will stimulate further thinking about Mary and will be seen as a substantial addition to the continuum of texts that do, and will, surround this notable artist.

A Note from Mary Pratt

As preparations for this book began, I was confronted with paintings, drawings and prints — all the work I'd done over a period of at least sixty-five years. Every image recalled its making — the place where it had its beginnings, the people I was involved with at that time and my own preoccupations while I worked.

It has been somewhat of a "sentimental journey." It has also been a privilege to be associated with everybody responsible for the creation of this book. They led me to believe that they all enjoyed the process — the gathering together of the paintings, all the photography and research for the essays, the careful process of acquiring the necessary funds to make this initiative, shared by The Rooms and the Art Gallery of Nova Scotia, a reality. They somehow made it all sound like fun.

Such generosity has not been lost on me. It has given me a new enthusiasm for my world and for my work. And if this book can give me the magic to jump over the hurdles of advancing age to produce paintings that are fresh and new, then that will be the best thanks I can give to everyone who has been involved — from cover to cover, from coast to coast.

Mary Pratt

Ned Pratt
Mary Pratt, 2012
photography
Collection of The Rooms Provincial Art Gallery

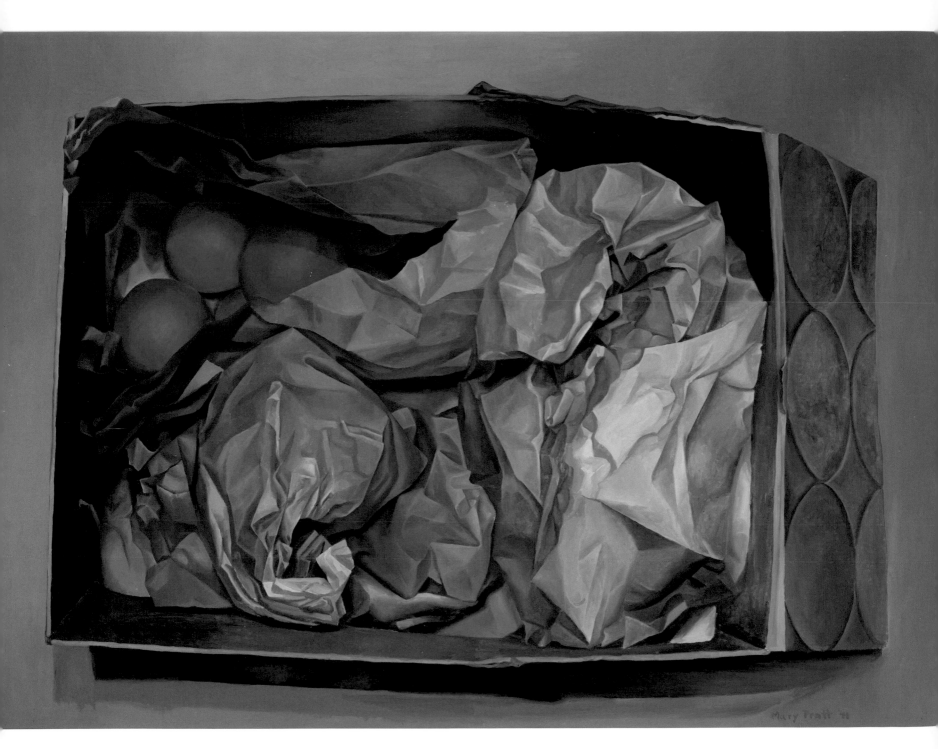

Bags, 1971
oil on Masonite
45.7 x 63.5 cm

Look, Here

MIREILLE EAGAN

I am the splendid impulse
That comes before the thought,
The joy and exaltation
Wherein the life is caught.
—Bliss Carman, "Earth Voices"

Words, patterns of words, stories, flickering like sun on the grass, while
underneath, cool as the turf, lay the meaning.
I considered the meaning.
—Mary Pratt, *A Personal Calligraphy*

MARY PRATT'S ART is an illumination rather than an illustration, one in which "everyday life" describes not just a reality close at hand but also aspects of life that lie hidden. Episodic, disjunctive, not grounded in particular narratives but rather alluding to them, Pratt's art gives form to the rich and complex feelings that hover over the mundane. For her, time is not dictated by clocks but ordered by daily rituals. Her images reveal a pattern of privacies, of things half-visible, half-said — but articulated, nonetheless. They represent a lifetime of looking closely, an intimation of the buzzing pause before one turns and continues.

Mary Pratt's works are deceptively simple, but great value lies in the subtlety of what she portrays. How can we, as the viewer, navigate what is hidden? We must start with what we know. Pratt offers us a clue: "To me, the surface is the given reality — the thin skin that shapes and holds those objects, which

we recognize as symbols. The fact of their place in the order of our lives is what I find most interesting. Because those facts must be personal to all of us, and so different in *particular* ways, though probably similar in *general* ways. One of the small puzzles that has plagued me since childhood has been the ideas of 'nothing in particular and everything in general' or 'nothing in general and everything in particular.'"[1]

Pratt's works of art show us representation in a particular place and time, and from this we form our statements and the structure of our visualizations. We live in a period of cultural transition, when contrary, and even contradictory, notions of art are in dispute. In this atmosphere, claims have been placed on Pratt for extraordinarily different reasons, generating stories of many Marys — Mary West, Mary Pratt, Mary Rosen — and the different facets of each. The scale changes depending on who is speaking.

Pratt's career is undeniably illustrious and kaleidoscopic, as are the texts and accolades that surround her. Her work is held by public art galleries across Canada and by private collectors internationally. Her images have become embedded in popular cul-

ture, anchoring posters, advertisements and postage stamps. She has endured the bureaucratic arena to become one of Canada's most substantial art advocates. She is the wellspring of a celebrated style of representation, particularly in the Atlantic provinces — a style that has become widely recognized and, naturally, rebelled against.

Despite her stature, Mary Pratt's work is often positioned outside the art historical canon. Lines are drawn connecting her to larger movements: she has been called a woman artist, an artist-wife, a Fredericton artist, a Newfoundland artist and so on. Writings on her work often draw on the biographical, with paintings aligned to events in her history. Yet attempts at narrating those intersections veer dangerously into tales of poverty and divorce, riches and love. Pratt herself makes little or no association with any school, label or category — and rightly so. Her works are not about a political attitude or about complicating what is seen. The complications come later.

First we will consider the relationship of the paintings to the climate in which they exist and how they

In the Bathroom Mirror, 1983
oil on Masonite
106.2 x 65.7 cm

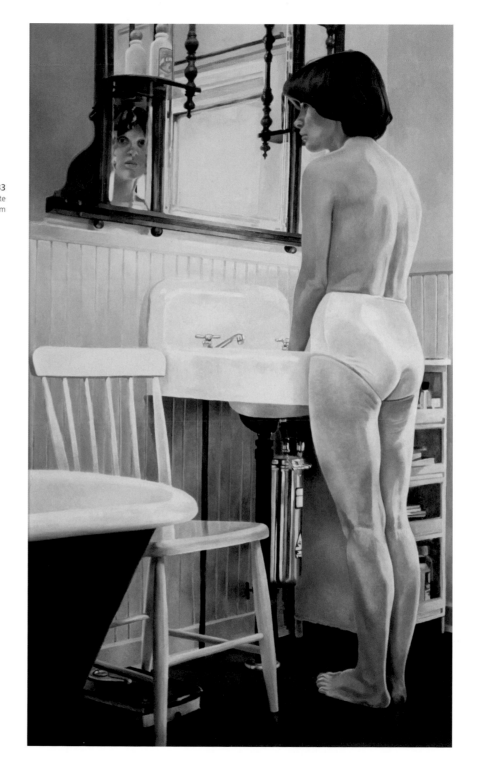

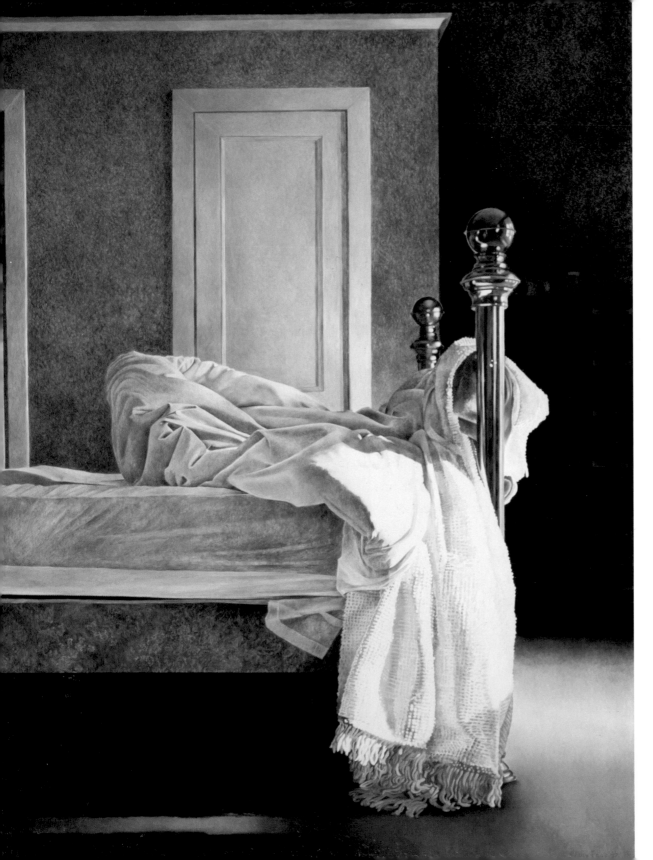

Bedroom, 1987
oil on Masonite
114.3 x 96.5 cm

compel attention in an effort to make meaning. This concerns not only what is shown but also what Pratt excludes from the imagery and why. Again, she gives us a clue as to how we should proceed: "To find a truth in yourself, surely you must start with the exactness of the image."[2]

Although her career is (as she describes it) "consistently inconsistent,"[3] Pratt has enduring preoccupations. She dwells on her surroundings, allowing a sideways autobiography through the objects and individuals that encompass her. However, she shows us not just the thing seen but also the thing as *being* seen. An artist of few direct self-portraits, her likeness is mainly glimpsed, in reflections on glass, metal, mirror. She plays with absence and presence, positioning herself as an observer rather than the observed. Ultimately, she asks the viewer to *see*; she tells us: "*Look, here.*" We follow Pratt as she portrays, again and again in various incarnations, deceptively innocuous still lifes, raw meat, women preparing for daily rituals and rites of passage, burnt offerings and large bonfires, living spaces devoid of inhabitants and objects moved by those who are unseen.

The formal qualities and quantity of the work show evidence of Pratt's physical attributes and, over time, the effects of aging. She has been nearsighted all her life, what she calls being the victim of "two unfortunate eyes,"[4] a condition that affects the formal depth of her paintings. As she ages, she is increasingly bothered by arthritis, which no longer allows her a full day in the studio. However, this affects execution rather than subject matter.

The paintings do not supply authoritative cues to how the viewer should read the work. The skilled but clinical translation of the viewed object to painted surface holds within it the artist's reason for selecting the object, which we can never fully know. Therefore, the paintings can be neither interpreted solely in terms of subject matter nor read exclusively as paint on surface. Yet one quickly recognizes a moment captured in time. Pratt refers to this consideration in various texts, as in her description of "the first time I knew disappointment"[5]: when she was six, she was struck by the beauty of a red sweater draped over the back of a chair. Although she was supposed to be cleaning up, she chose instead to leave it, so that

Romancing the Casserole, 1985
oil on Masonite
50.8 x 71.1 cm

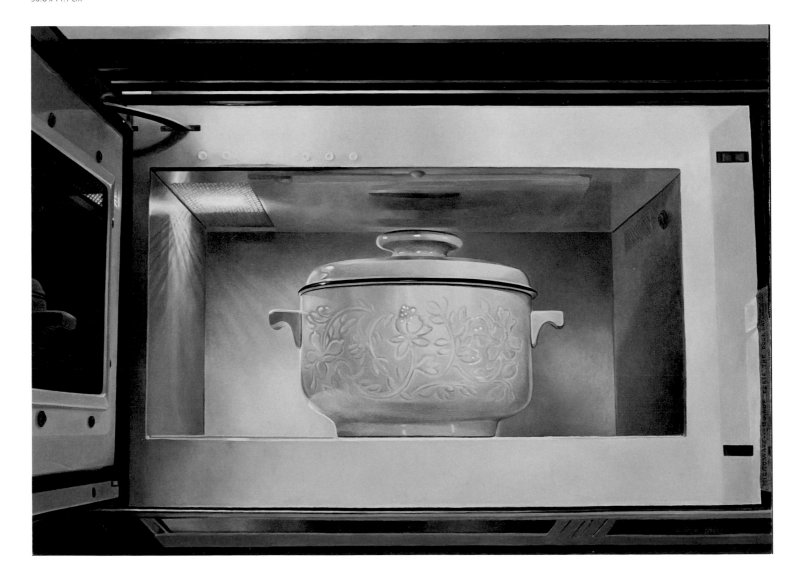

she could continue to admire its folds. When she returned from school the next day, the sweater was put away. She was "furious, because it meant she could never again see the red folds exactly as she had seen them before."[6] In her later journals, Pratt recounts her desire to preserve her surroundings in spite of (or perhaps because of) the lingering knowledge of her daily tasks: "The ability to find intensity in other things, the apparently inanimate, is a useful recourse. It serves me well. It allows me solitary moments of intense bliss. It asks nothing and gives everything. Usually, I keep the emptiness in check. Fill it with chores that amuse me...But the trouble is, of course, that the season of desire is still with me."[7]

Pratt maintained her stylistic and thematic choices through the various weather patterns of the "isms" to which she was associated — in particular, photorealism and feminist art during the 1960s, '70s and '80s. Certainly her work parallels the rise of photorealism, with its unironic view of social scenarios and lingering allegiances to the Modernist era. Harnessing the camera as a tool to gather information that was then translated into painting, photorealism's underlying argument was that the grand dramas of Modernist abstraction and minimalism could not account for the stories of everyday life. The movement did, however, adopt a Modernist dictum for detached formalist images that often refused to provide commentary on personal and political matters and, in fact, valued the ambiguity of such a stance.

Pratt's art is regularly positioned with the feminist movement, which operated under the umbrella of politics rather than aesthetics. Generally portraying middle-class women's art with an emphasis on the quotidian domestic sphere, feminist theory responded to and questioned conventions of art history. The movement was integral to a paradigm shift within art history and art criticism, when its members remedied exclusion of women from previous writings. The Canadian art world echoed these broader trends, following suit as substantial changes in art production resulted in the collapse of traditional categories and the rethinking of materials. Mary Pratt continued painting regardless. Although she did explore a variety of materials, she maintained ownership over a medium that was well suited to her purposes.

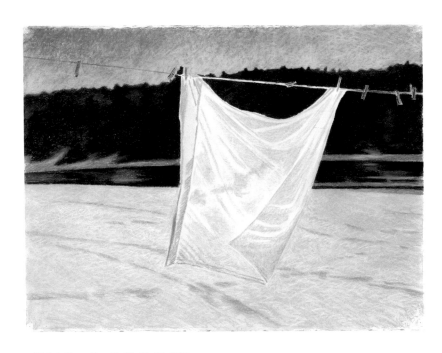 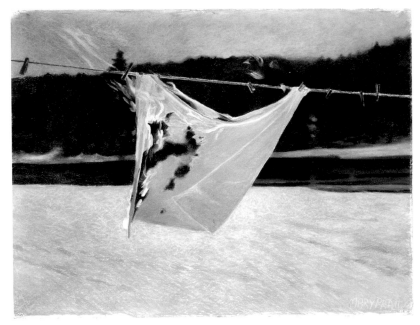

Dishcloth on Line #1, #2, #3, #4, 1997
mixed media on paper
57.2 x 76.2 cm (each)

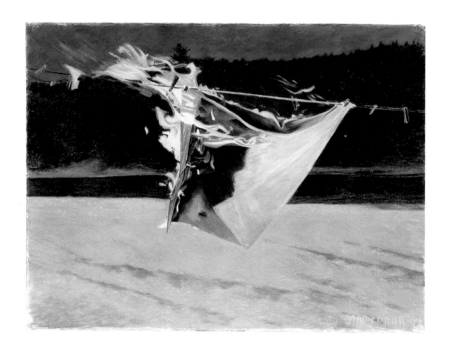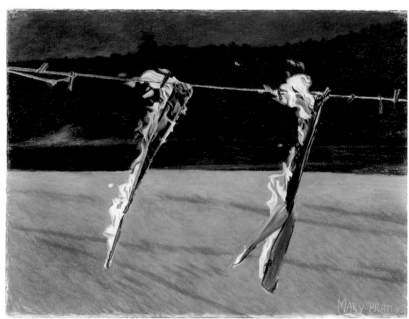

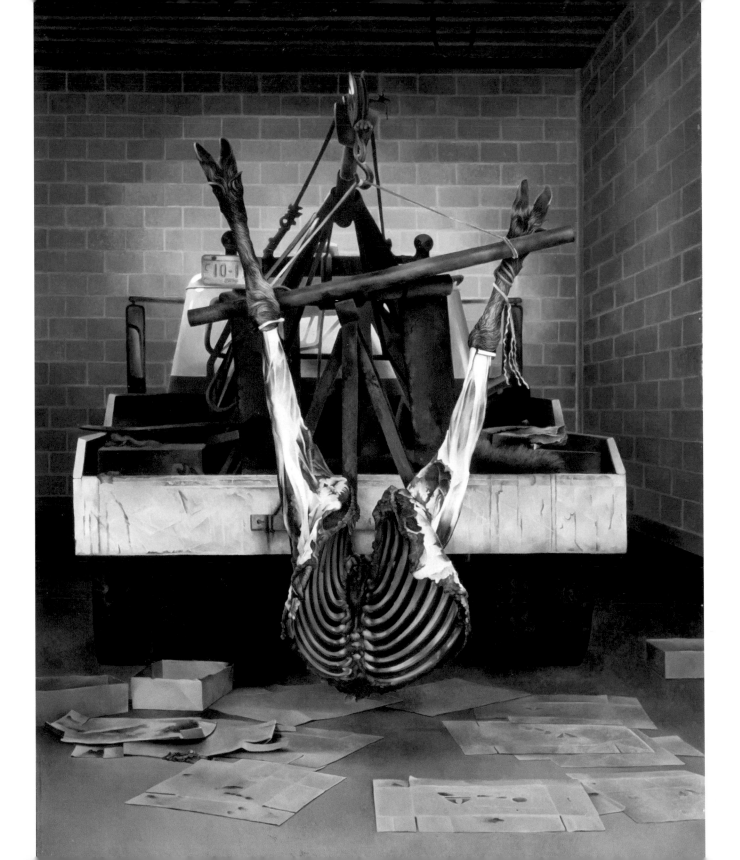

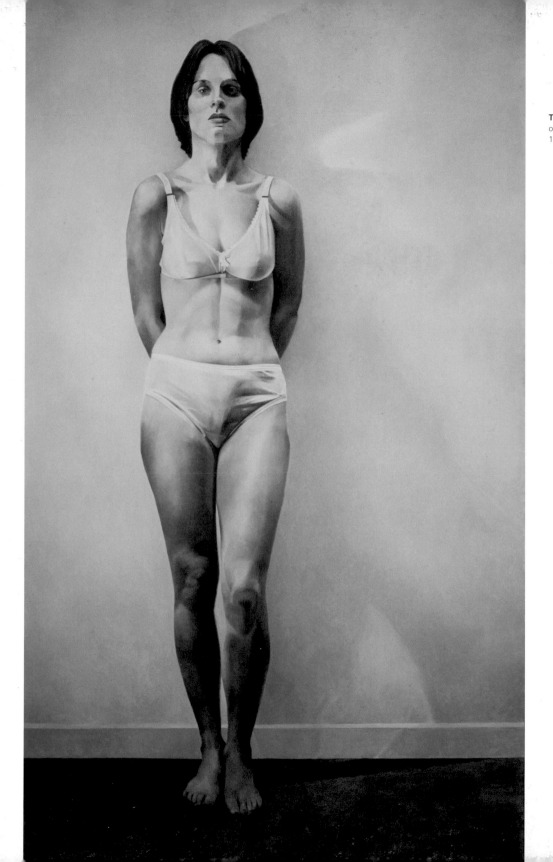

This Is Donna, 1987
oil on canvas
185.4 x 106.7 cm

facing page:
Service Station, 1978
oil on Masonite
101.6 x 76.2 cm

Bowl'd Banana, 1981
oil on gesso on Masonite
60.9 x 50.8 cm

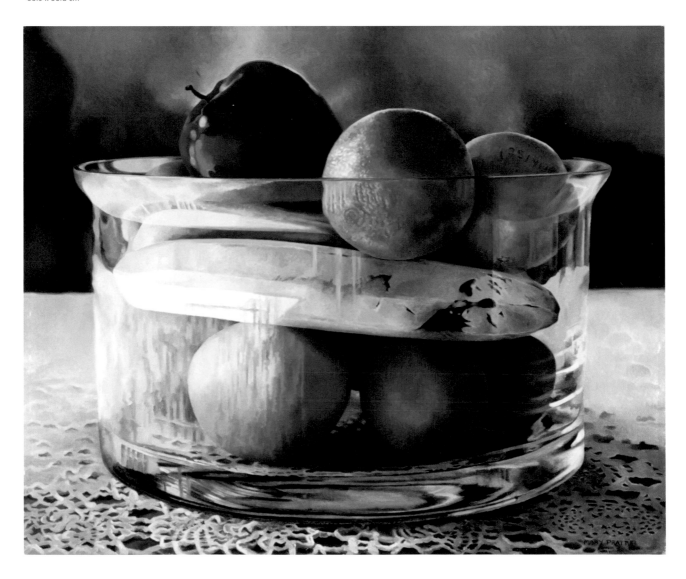

Pratt's approach should not be read as political indifference; instead, it can be conceived of as strategic. She wants us to look and not be distracted. In her desire not to be misunderstood or overshadowed by excess commentary, she makes her work intelligible and without affectation. Even in her more uncanny pieces, such as *Service Station* (1978) or *This Is Donna* (1987), the details have been moderated. Her work is free of exaggeration or sharp breaks; her light does not consume. If darkness does appear, it is not allowed to prevail.

Compare three works by Pratt: *Bowl'd Banana* (1981), *Christmas Fire* (1981) and *Girl in Glitz* (1987).[8] In each, she deftly presents nuance of form, intensity of atmosphere and complexity of affect. In *Bowl'd Banana,* the composition of the painting evokes the traditional still-life genre. There is the sense of the moment having stopped at the point of both maximum presence and salience. Describing a surface somewhat unwilling to draw attention to itself, the light seals the profound isolation and inwardness of the fruit contained by a glass bowl. The second work, *Christmas Fire,* traces a moment in process rather than stilled. It is fire as a verb. Light hits in a storm of particles, as the movement of the flames is echoed in the outlines of tree branches in the background. The image is anchored by a fence, which separates wild nature from the backyard, and a solid piece of wood in the centre of the fire. The third work, *Girl in Glitz,* is equal parts scene and encounter. Theatrically lit, the subject is closely cropped and no background is provided. Despite the model's reclining position, she verges on being confrontational. The girl is in undergarments, carrying the indentations of clothing recently removed. Pratt's brushwork is precise, and she has chosen to emphasize particular features such as the eyes, the stomach, the breasts and the arm poised between the viewer and subject. It is rare for Pratt's subjects to stare back at the viewer — but when they do, they are notably self-possessed.

Like most of what she has created, each of these three paintings is full of sentiment while dispensing with unnecessary clutter. She has gathered what she found beautiful, and it is the character of her everyday life that has brought the beauty forth — the objects and instances that were there, then. Yet, her

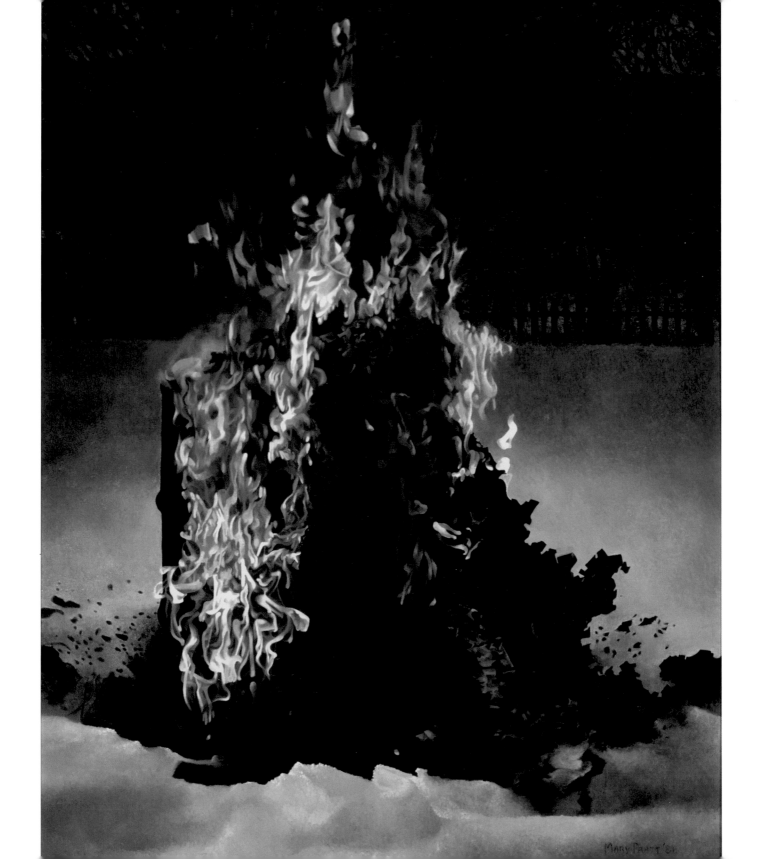

Christmas Fire, 1981
oil on Masonite
76.2 x 59.7 cm

visual language is so finely tuned that it dispels any emotional narrative. At the same time, her imagery undergoes an absolute submersion in those emotions and the world of longing they conjure. This is not unusual: Western art is full of such paradoxical moments — some have flourish, some are quiet. However, by pointing to these particular qualities in Pratt's work, we can show their strengths.

. . .

"At a certain point," writes art historian David P. Silcox, "if images are strong enough and profound enough, and if they are sufficiently broad in their appeal, they achieve the status of symbol. That is, they come to stand for something more complex and comprehensive than what they simply describe or depict, and they evoke emotions and responses that are powerful."[9] How does one achieve this? How does one strike a balance between making demands on one's viewers and permitting an atmosphere in which they can have a direct response to the work? Pratt treads with intention. She speaks a language

that is concise, shining a light on the most banal but surprisingly poignant aspects of existence. She rings true. As a result, hers are creations that urge, press and transform this current period, whether they intend to or not. Her works install in us, even with their constraint, all the codes we need.

Pratt is not readily considered a contemporary artist by curatorial and critical tastemakers. "Contemporary" can be a default category, referring to any work produced in the present. The word is often applied to artists who are considered savvy, timely, in constant motion. Pratt's paintings are too private and too immediate for such a modish consideration.

Arguably, when one coincides too well (perhaps too self-consciously) with trends in art, one is in danger of being short-sighted, of being too reliant on the costumes of an era. In his essay "What Is the Contemporary?," the philosopher Giorgio Agamben states: "Those who are truly contemporary, who truly belong to their time, are those who neither perfectly coincide with it nor adjust themselves to its demands…But precisely because of this condition, precisely through

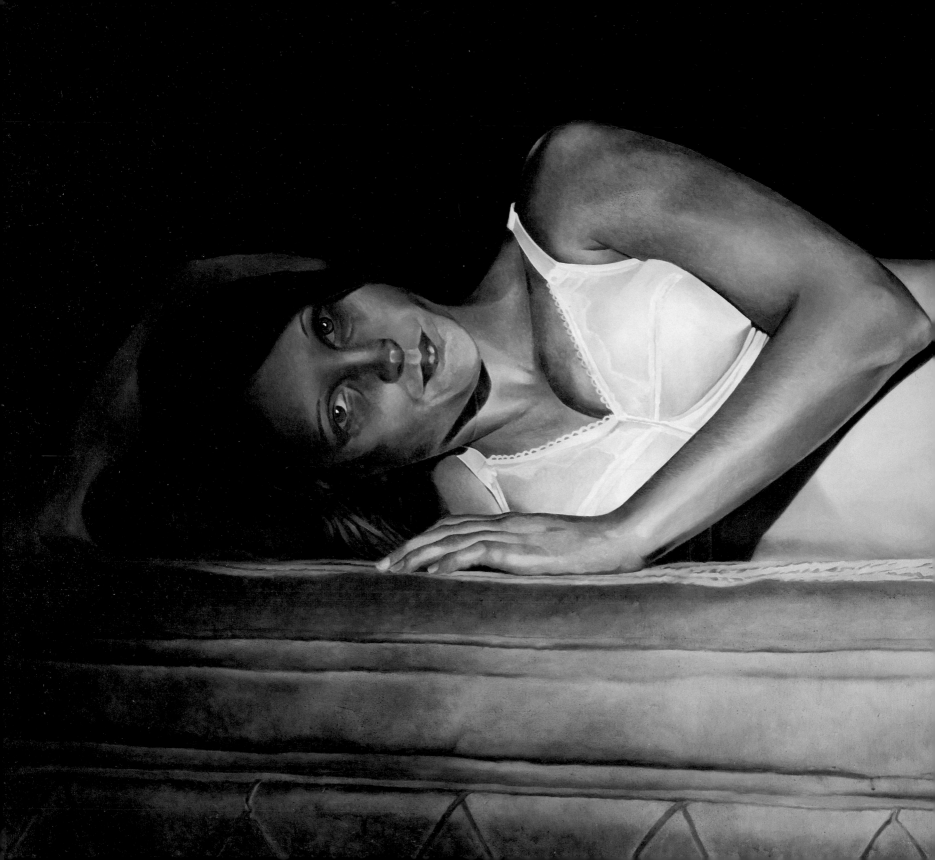

Girl in Glitz (detail), 1987
oil on Masonite
76.2 x 114. 9 cm

this rejection and this anachronism, they are more capable than others of perceiving and grasping their own time."[10]

For this reason, Pratt has staying power. With the passage of time come efforts to measure its continuity, to understand where we come from and where we shall go. The answer may be right in front of us. In a convocation speech in 1994 to graduates of Cabot College of Applied Arts, St. John's, Pratt said: "As the world grows smaller, and as information becomes ever more readily available, it is important to remember that all of it is old information, coming to us from places through the eyes of other people. Wonderful, valuable, useful. But for all its value, it must not bedazzle us. We must not be blinded to Newfoundland itself."[11]

Pratt is talking not only about a location — Newfoundland — but also about lived experience grounded in a specific place. What she describes is a layered location abounding with histories and memories as broad as they are deep.[12]

It is in that world of remembering that truth can be found, the superficial truth of social patterns — and, underneath that, the truth of our primary concerns. Through art, poetry and song, we convey to others our joys and trials. The appeal of cultural trends can distract momentarily, but there will always be a place for that which strikes a common chord. We return to here, to you, to me, to Mary, in the act of encountering. ▪

Fish Head in Steel Sink, 1983
oil on Masonite
52.1 x 77.5 cm

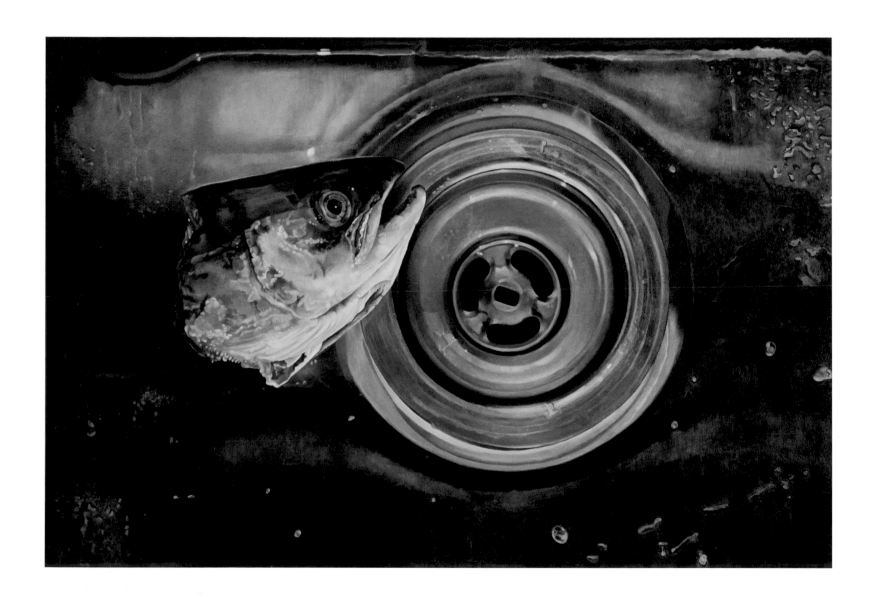

Lupins in Christopher's Burned Studio, 1996
oil on canvas
50.8 x 40.6 cm

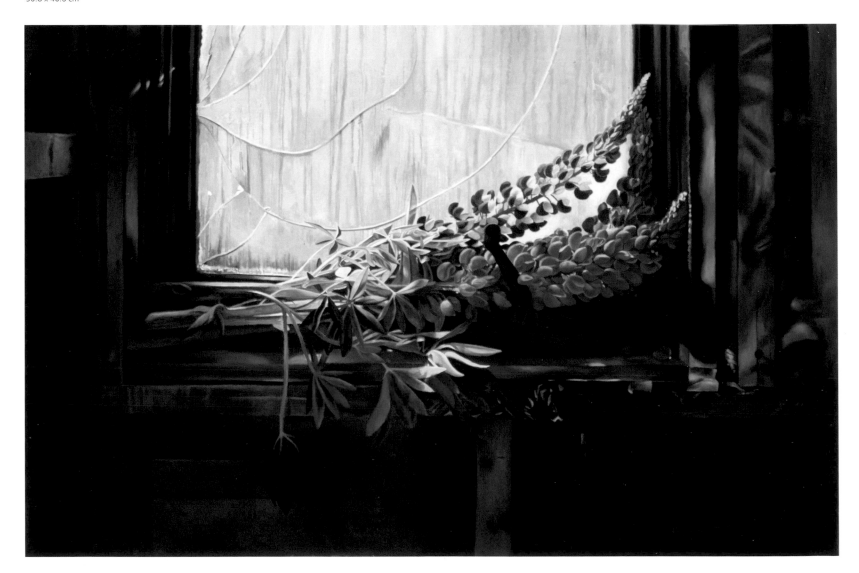

Between the Dark and the Daylight, 2011
oil on canvas
50.8 x 76.2 cm

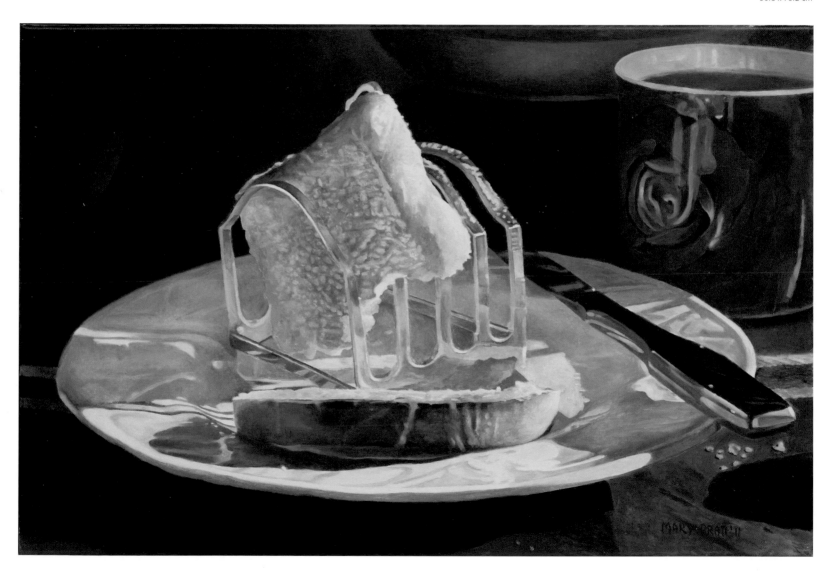

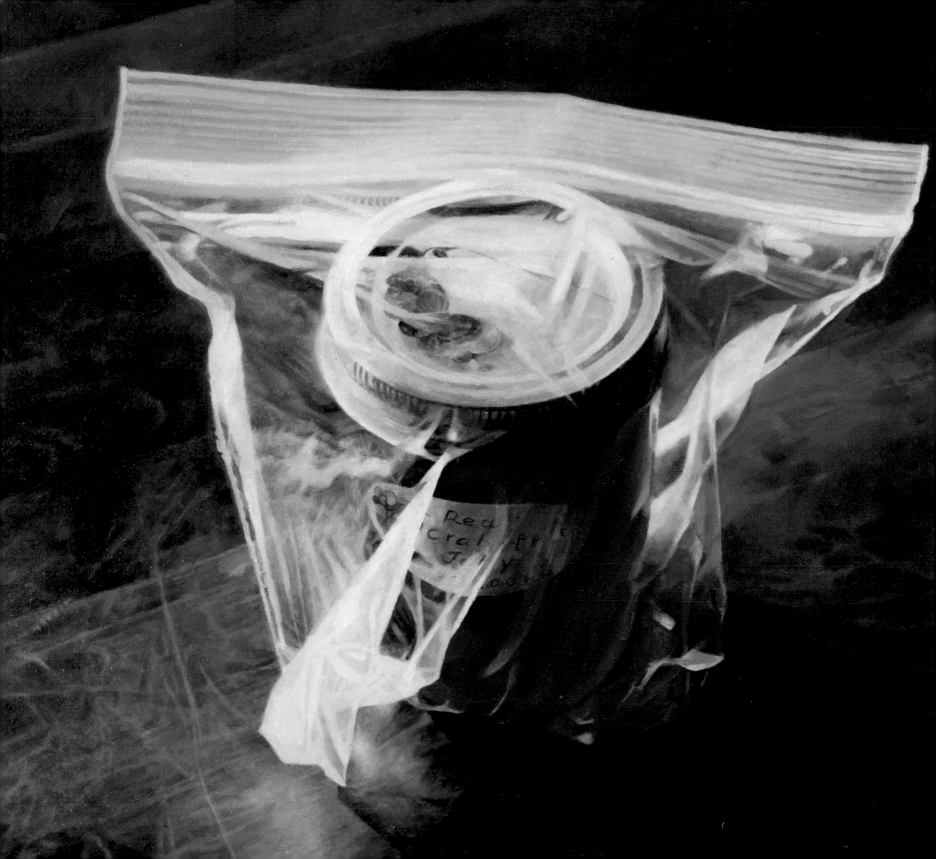

Specimen from Another Time (detail), 2001
oil on canvas
55.9 x 71.1 cm

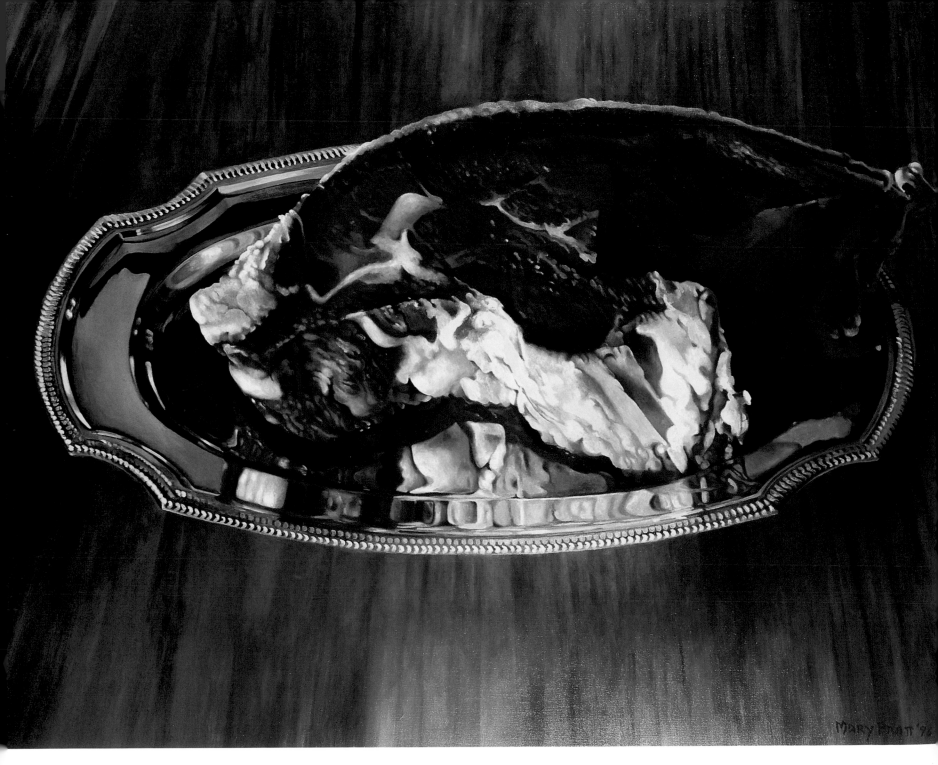

Sunday Dinner (detail), 1996
oil on canvas
91.4 x 121.9 cm

Vanitas

SARAH FILLMORE

I FIRST MET Mary Pratt at her home in St. John's. She served pecan bars and they looked, as you would expect, perfect. White china teacups were nestled inside one another on a tray set on the kitchen counter. Tulips sprawled in a cut-glass vase on a white lace tablecloth. It all made sense: Mary Pratt's home serves as inspiration — why look any further than the world around her? In her home we are faced with the real thing: the "real" bowl of fruit, the "real" jar of jelly or the "real" sink full of dishes. (Though let's be clear: there was no sink full of dishes on the occasion of my visit.)

Often described as a painter of "women's stuff" — of kitchens and cakes, of dinner preparations and sparkling jars of jelly — Mary Pratt paints what she sees: "the stuff of life, that stuff that everyone touches every day, the stuff that a woman understands."[1] She not only paints what women see and understand, but she also elevates the subject through her skilful, glowing treatment in paint on Masonite, thus celebrating and monumentalizing the "stuff of life."

Like other contemporary artists, Pratt deals in the concept of "real." She uses paint where others use sculpture, photography, film or performance art. Pratt's mature use of subject matter demands a new reading of still life — and *vanitas* genre paintings in particular — which has contributed to a renewed interest in her work.

The lure of "capturing the real" is especially strong in Mary Pratt's work. Her paintings present as moments in time — moments that she felt moved to preserve. She describes the impulse: "Seeing the groceries come in, for instance. Or cooking. I'm getting supper and suddenly I look at the roast in the oven or

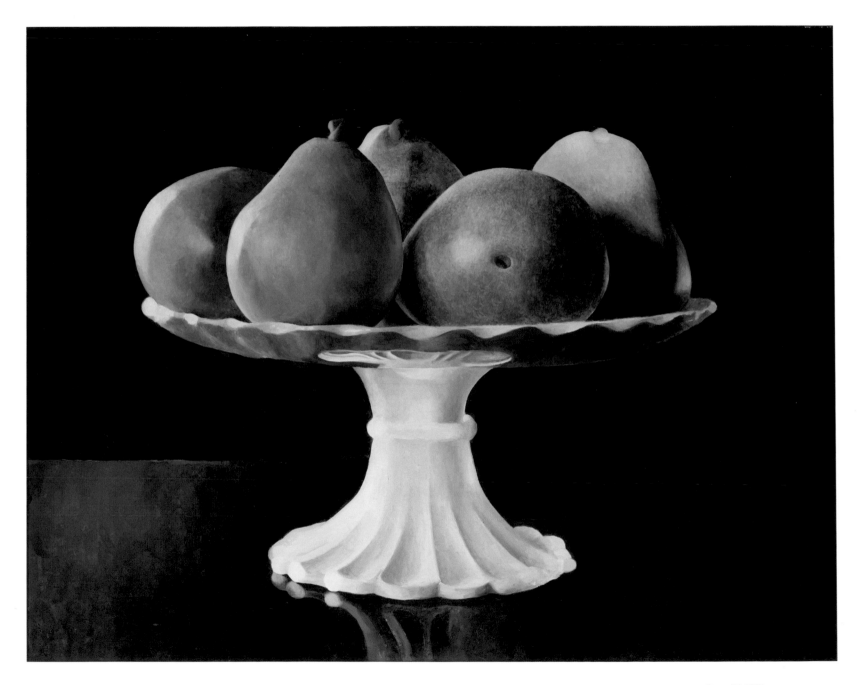

Pears #1, 1971
oil on Masonite
35.5 x 45.6 cm

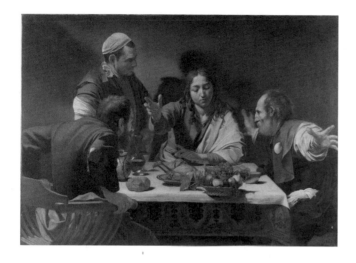

Michelangelo Merisi da Caravaggio (1573-1610)
The Supper at Emmaus, 1601
oil and tempera on canvas
Presented by the Hon. George Vernon, 1839 (NG 172)
© National Gallery, London/Art Resource, NY

the cod fillet spread out on the foil, and I get this gut reaction. I think 'that's gorgeous, that's absolutely wonderful and I must save it.'"[2]

That impulse is shared: it comes from a longing to hold truth in your hands, to feel something of your own existence — a longing to feel alive. American writer Siri Hustvedt notes: "Still life is the art of the small thing, an art of holding on to the bits and pieces of our lives."[3] Mary Pratt's paintings are not restricted to still life, but they are the ones that catch my eye. It is the sense of light they capture. The painting of the jelly jar is really about the way the light shines through the glass, the way that light is preserved, like the jelly, for all time.

When faced with great works of art, we tap into memories and smells, emotions and flavours, and

experience familiar longings. I am by nature drawn to the light captured in Pratt's work, the way the glass embraces the fruit in *Bowl'd Banana* (1981). I recognize that same obsession with light in the work of Caravaggio, Vermeer, Pieter de Hooch and Jean-Baptiste-Siméon Chardin. As with the work of these great painters from the past, Mary Pratt's paintings transcend time and place. Her subjects promise a bounty to come, dinners ahead, a breakfast for one, a mango sliced for a picnic. Just as the fresh grapes in Caravaggio's *The Supper at Emmaus* (1601) remain fresh and juicy through the centuries, Pratt has set the dinner table to feed our eternal soul.

Italo Calvino wrote, "Nobody looks at the moon in the afternoon, and this is the moment when it would most require our attention, since its existence is still in doubt."[4] Calvino's musings offer a lens through which to view Pratt's work. Her paintings reveal the elements that embody desire and life, and the satisfaction therein. They also convey intimations of mortality, holding our desires in check.

Caravaggio, Harmen Steenwyck and Théodore Géricault, to name only three, painted pictures that

told of morality, mortality and the stuff of life. Some of their paintings fall into the still-life category of *vanitas*. These works were often dense with symbols: skulls, money, gold, books, rotting or fresh fruit, flowers in various states of bloom and decay. *Vanitas* paintings showcased the artist's skill in handling paint and translating light. They were also warnings of the fleeting nature of life.

Pratt follows this tradition in her work, setting the composition simply, highlighting the main subject without distraction or clutter. Although many stories have been read into her simple subjects and pared-down compositions, Pratt doesn't feel the need to narrate the scene. Her interests remain colour, light and the play of both on surface. As art historian Paddy O'Brien comments, Mary Pratt places items on plastic wrap or foil instead of traditional drapery.[5] In so doing, her challenge is equal to, if not greater than, the challenges of those masters who came before her.

In her book on still-life painting, Erika Langmuir alludes to the genre's ability to preserve flowers, fruit or summer forever.[6] She describes the still life in the biblical scene *The Supper at Emmaus*: "By means of 'the true imitation of nature,' Caravaggio makes us witness the miraculous suspension of nature's laws."[7] As art historian Norman Bryson writes:

Still life as a category within art criticism is almost as old as still life painting itself. The first modern still life showing such things as fruit, baskets, goblets, bowls, as independent pictures (not just details or margins in religious scenes) dates from the early 1600s: by the 1600s the French Academy already finds a place for still life in its aesthetic debates…In the later eighteenth century, Reynolds formulates a theory of still life in the Discourses, in which it features as a distinct branch of painting, taking its place alongside portraiture, landscape and history painting.[8]

During my recent visit to Mary Pratt's home, she mentioned that this exhibition of her work would be the first since her trip to Europe in 2008 to see the great galleries of Italy and Spain with her second husband, James Rosen. True to character, she fought

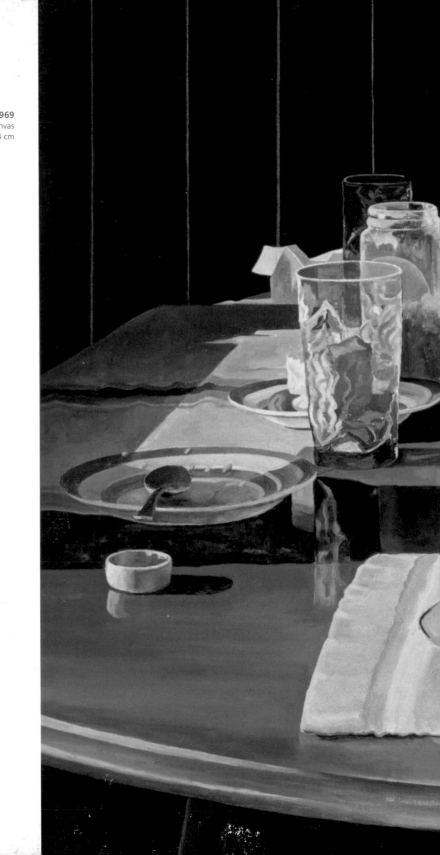

Supper Table (detail), 1969
oil on canvas
61.0 x 91.4 cm

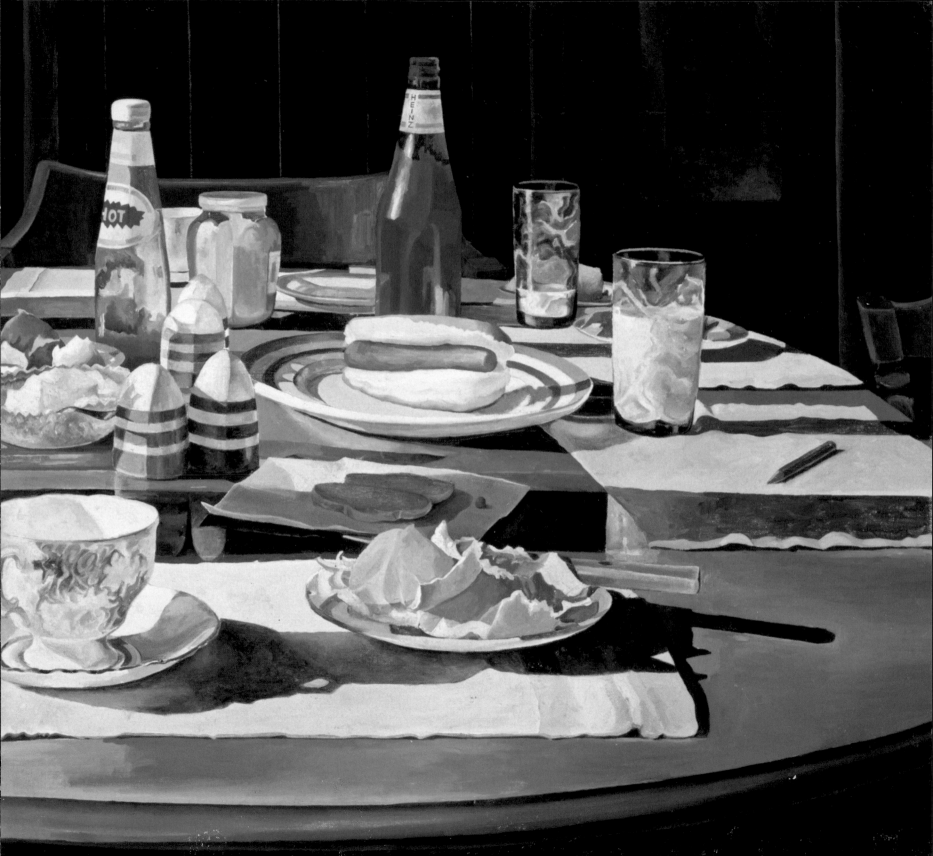

the mindset that she should "love everything."[9] She was impressed by the work of Giotto and Goya in particular but felt confirmed in her belief that — in her own practice — art comes from life.

Pratt's paintings create a still moment, one in which we can taste, smell and feel the elements just out of reach — inside the picture frame. As Hustvedt suggests, "A painting creates an illusion of an eternal present, a place where my eyes can rest as if the clock has magically stopped ticking."[10] In her work, she has cheated death, stopping the clock for that second and thus extending desire.

Mary Pratt's training at Mount Allison University centred on still life painting; it was the basis of her education in fine arts. In *The Art of Mary Pratt: The Substance of Light,* Tom Smart describes her classes: "Mary was drilled in the basics of drawing, design, sculpture and working from still life before she was allowed to move on to a less structured senior year."[11] The still-life painting studio focused on design, both in the arrangement and treatment of groups of static objects and in the employment of the various techniques used in oil, watercolour and tempera painting.[12]

In 1957, once out of school and married to fellow student and painter Christopher Pratt, Mary Pratt moved first to Glasgow, Scotland, where Christopher was a student at the Glasgow School of Art. In 1963, the family settled in the remote community near Salmonier, Newfoundland. There she fit painting into and around her various duties as wife and mother. With little time to construct scenes from which she could paint, and finding that her preferred subject matter often perished before a new painting was complete, she eventually discovered the tool that she needed to stop time: the camera. Smart notes that her use of the camera was also a response to the unpredictability of light in Newfoundland: "The light wouldn't stand still long enough for me to catch it," she has said (nor could fish be left sitting on the kitchen counter for long).[13]

Supper Table (1969) was the first painting that Mary Pratt made using a photograph. Christopher Pratt preferred slide film, which was particularly good at catching the light. These images allowed her to paint slowly: "The camera was my instrument of liberation. Now that I no longer had to paint on the

run, I could pay each gut reaction its proper homage. I could paint anything that appealed to me: Barby eating an ice-cream cone, a dish of trifle in the garden, whatever. It also meant that I didn't have to fuss all the time about the drawing. I could use the slide to establish the drawing and concentrate on the light, and the content and the symbolism."[14]

In this day of highly stylized food photography ("food porn"), Mary Pratt's work seems ahead of the curve. She imbues her subjects — fish on tin foil, eviscerated chickens or a cut of beef ready for the oven — with a heightened presence and overwhelming sensuality. Like the *vanitas* paintings of the past, Pratt tempts us with the richness of this world.

In *Sunday Dinner* (1996), the glistening cut of meat, slightly out of focus on a shining silver platter, creates a powerful version of reality. What we are seeing, of course, is true — the image painted is the one that was photographed. Steve Edwards, in his short introduction to photography, explains: "Human vision is binocular, rather than monocular: Looking with two eyes spaced roughly 6 centimetres apart allows us to register spatial depth. This has important consequences for looking at pictures, because binocular vision enables us to see the flat picture surface as well as the depicted scene."[15]

It is precisely this that contributes to Mary Pratt's work being unsettling, discomforting and affecting. Its off-kilter aesthetic and truth in representation put the viewer on edge. Our eyes and brain are unable to reconcile the flattened image with what we know to be "true."

Pratt's use of photographs becomes a point of interest when we see the detachment between artist and photographer. Describing a scene that recently caught her eye, she told me that she "asked Ned [her son] to get the camera."[16] As she says: "The photos and the paintings find me."[17] Despite this somewhat romantic notion, Pratt approaches each painting with a cold, clear eye. She uses photography to maintain objectivity. In her words, "The photograph keeps me cold. There's no room for being messy and nostalgic."[18]

The use of photography to inform her work was introduced early in Pratt's education: "Her classes at the Art Centre were balanced by others given

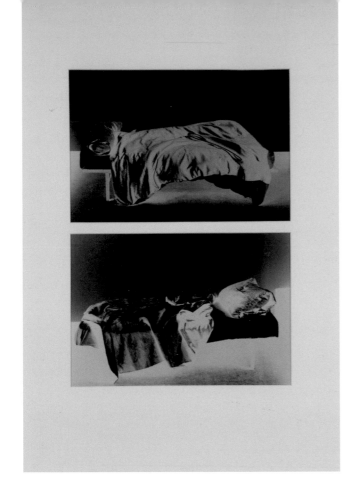

by John Todd, a graphic artist and illustrator who set up a small studio serving the printing presses of Fredericton. Trained in New York at the Pratt Institute, Todd brought to Fredericton an appreciation of photography as a source of images in the commercial art business."[19] Those commercial images informed Pratt's aesthetic development and helped foster her predilection for smooth, glossy surfaces and streamlined composition. But the decision to use photography in her painting practice, beginning in 1969, was first and foremost a practical one, as described above.

The undercurrent of desire is strong in Pratt's treatment of her subject matter — be it in the silky flesh of filleted fish (*Cod Fillets in Cardboard Cartons*, 1975), the shiny, taut tent of a turkey under foil (*Christmas Turkey*, 1980) or the glossy table of a patio scene (*Artifacts on Astroturf*, 1982). Her everyday subjects glisten and quiver, ripe and ready to be savoured.

I return to the idea of *vanitas*. Pratt's lush and luminous pictures allow us to see our world through new eyes. Her work resonates not only with painters of years gone by but also with artists of her generation. Montreal artist Sorel Cohen's work questions our relationship to and perceptions of "women's work." Through her performances and photographs in *Bed of Want* (1993), Cohen makes the most intimate of spaces — the bed — the subject of inquiry. Her photographs of an empty, unmade bed are presented as negative prints — the black and white are reversed — evoking forensic documentation. How long has the bed been vacant? Who was last in it? Was this a sick bed? A marital bed? Did a mother nurse a child here?

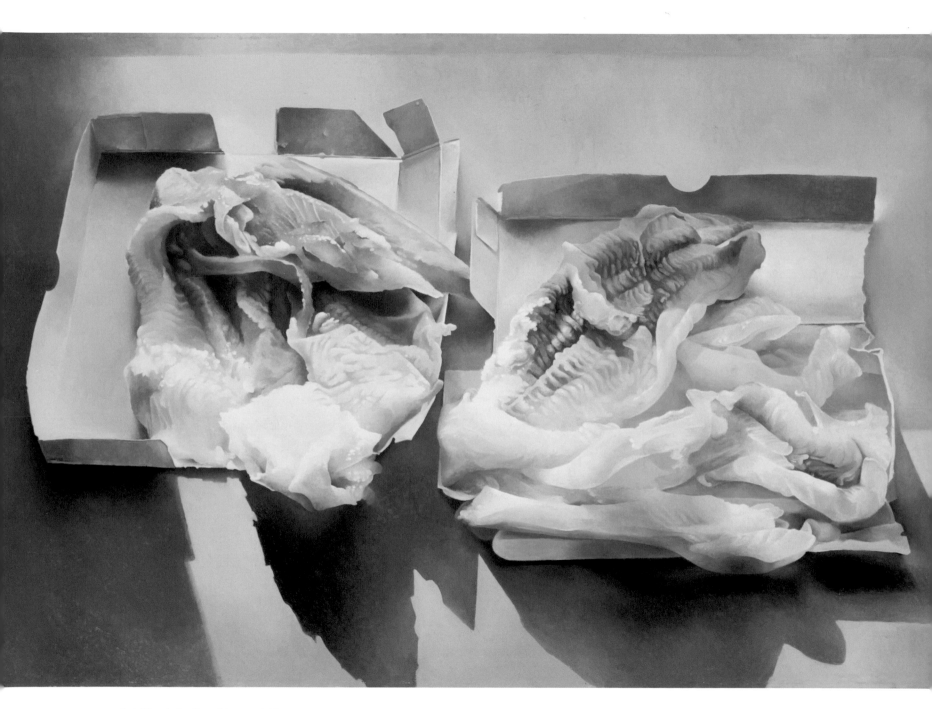

Cod Fillets in Cardboard Cartons, 1975
oil on Masonite
49.5 x 73.0 cm

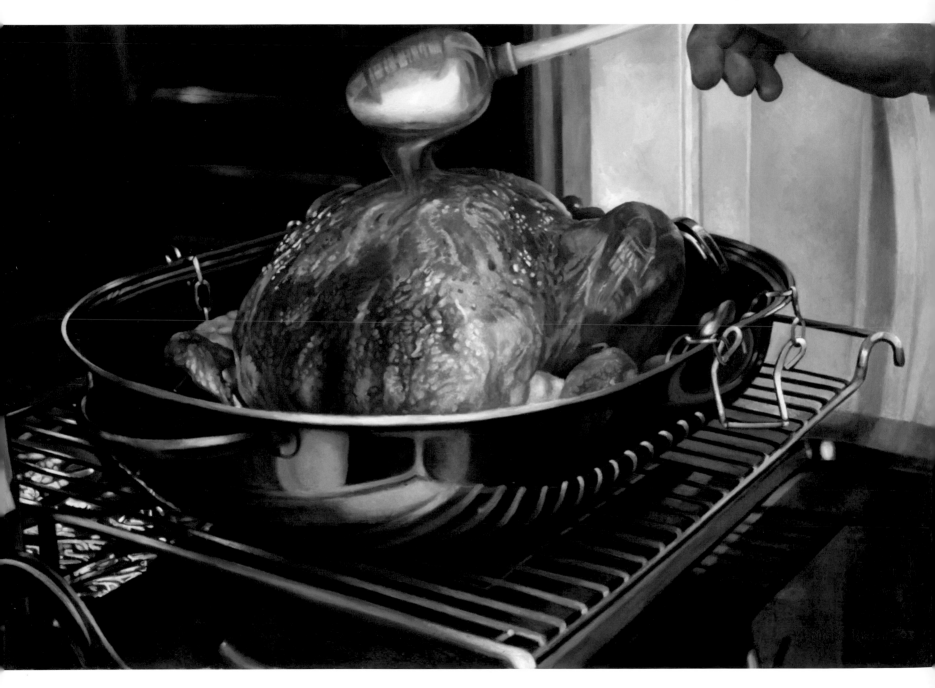

Basting the Turkey, 2003
oil on canvas
40.6 x 43.2 cm

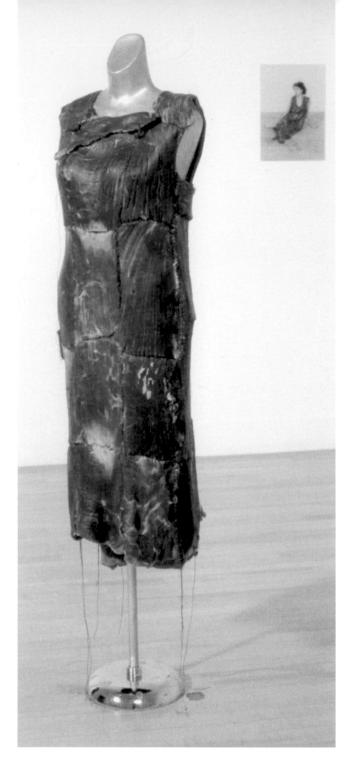

Jana Sterbak
Vanitas: Flesh Dress for an Albino Anorectic
sculpture

She also raises questions of domesticity: Whose job is it to make this bed? And ultimately, why put this object under this level of scrutiny? The same may be asked of Pratt's subjects. Why immortalize a cut of beef, ready for Sunday dinner?

The roast of beef, prepared to feed a family, is the centrepiece at the dinner table. I am reminded of Jana Sterbak's "flesh dress." *Vanitas: Flesh Dress for an Albino Anorectic* (1987) is remade for each exhibition from twenty kilograms of flank steak. The meat is prepared, heavily salted, cut to pattern and sewn to form a dress, which hangs and desiccates over the course of the exhibition. The ideas of desire, consumption and beauty are all called into question by this powerful work. *Vanitas* — a warning, a call to action.

Mary Pratt tells me: "In order to be a good painter, you have to live a full life."[20] She is heeding the implied warning in her own paintings — *vanitas* translates from Latin as "emptiness." The careful, minute reading of everyday moments, paused for eternity by Pratt's hand, prevents a life of emptiness and guarantees, instead, a full life. ∎

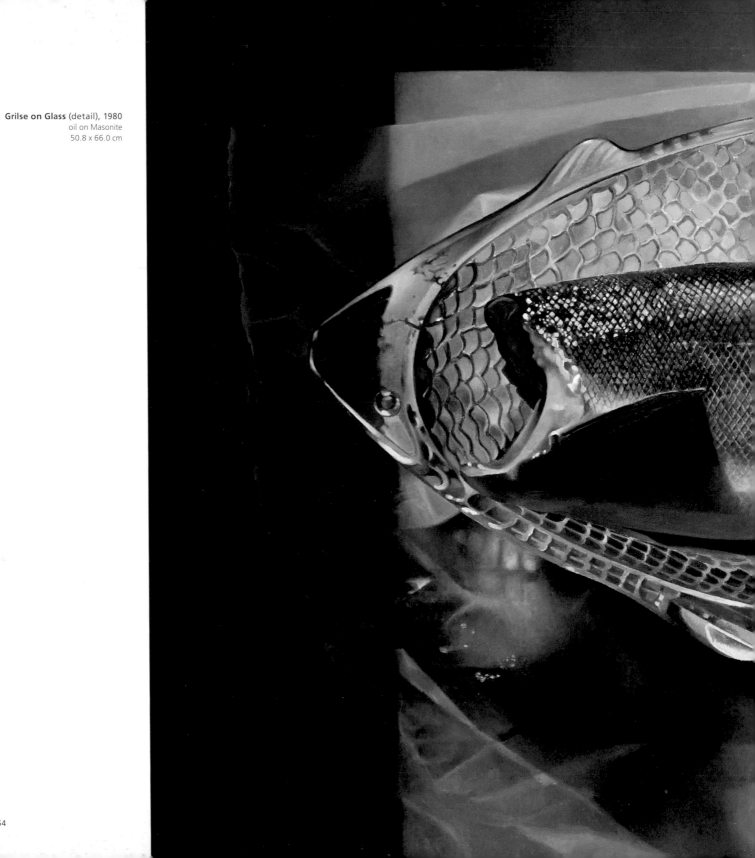

Grilse on Glass (detail), 1980
oil on Masonite
50.8 x 66.0 cm

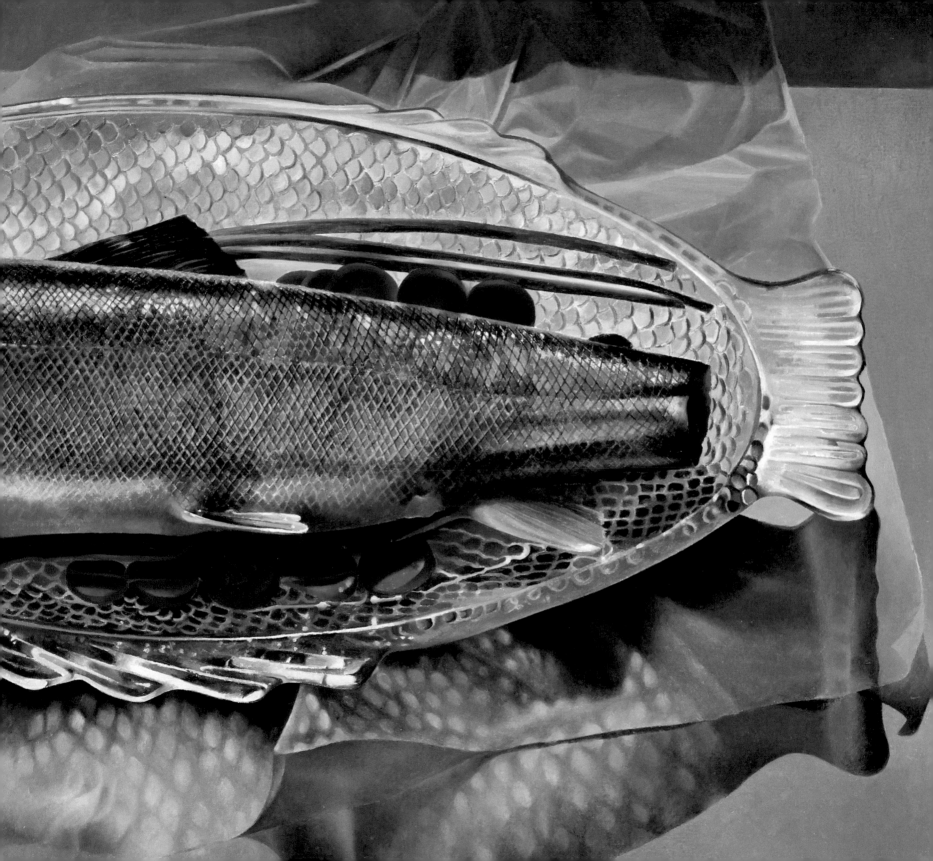

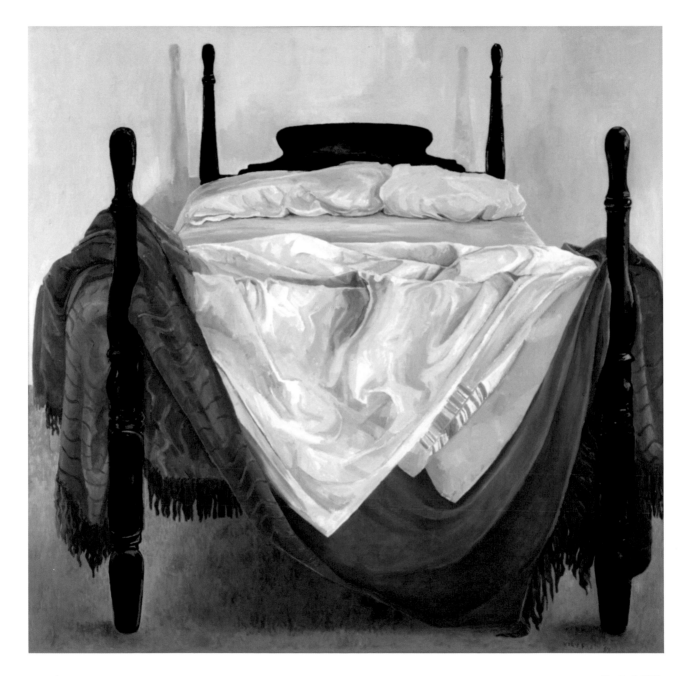

The Bed, 1968
oil on canvas
91.4 x 91.4 cm

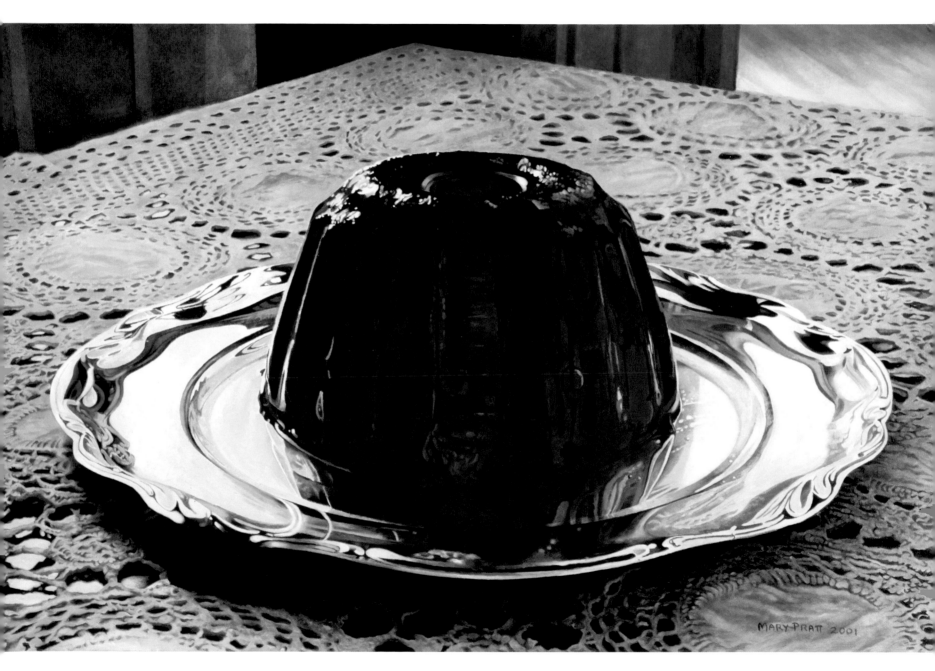

Jello on Silver Platter, 2001
oil on canvas
61.0 x 91.4 cm

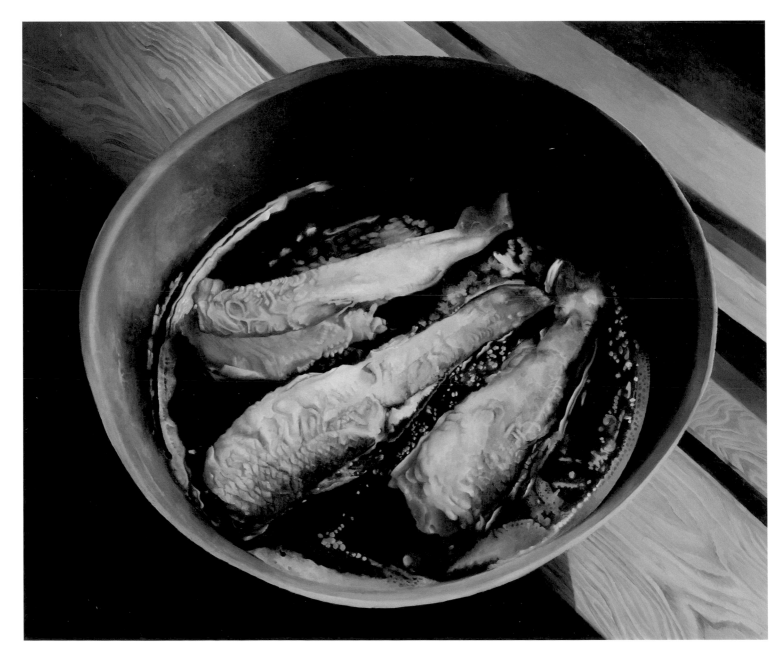

Trout in Pan (Frying Trout), 1971
oil on Masonite
43.2 x 53.3 cm

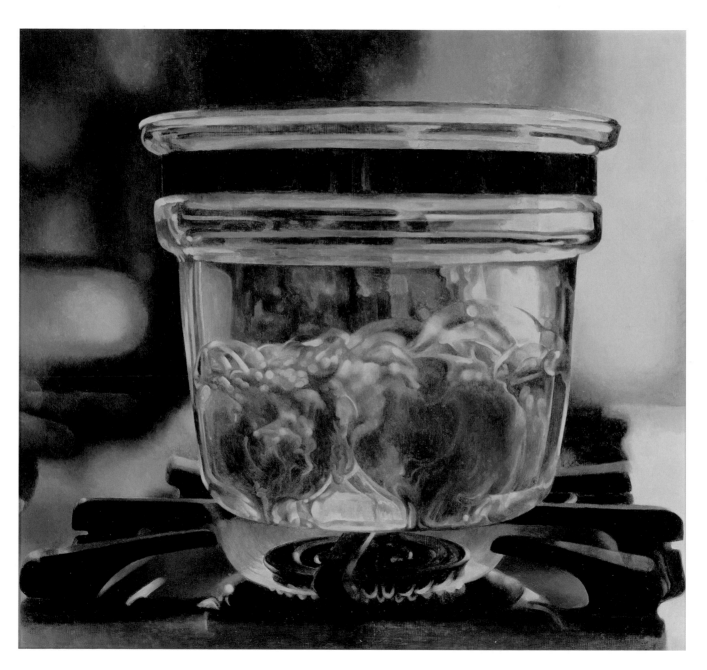

Pyrex on Gas Flame, 1977
oil on Masonite
30.5 x 33.5 cm

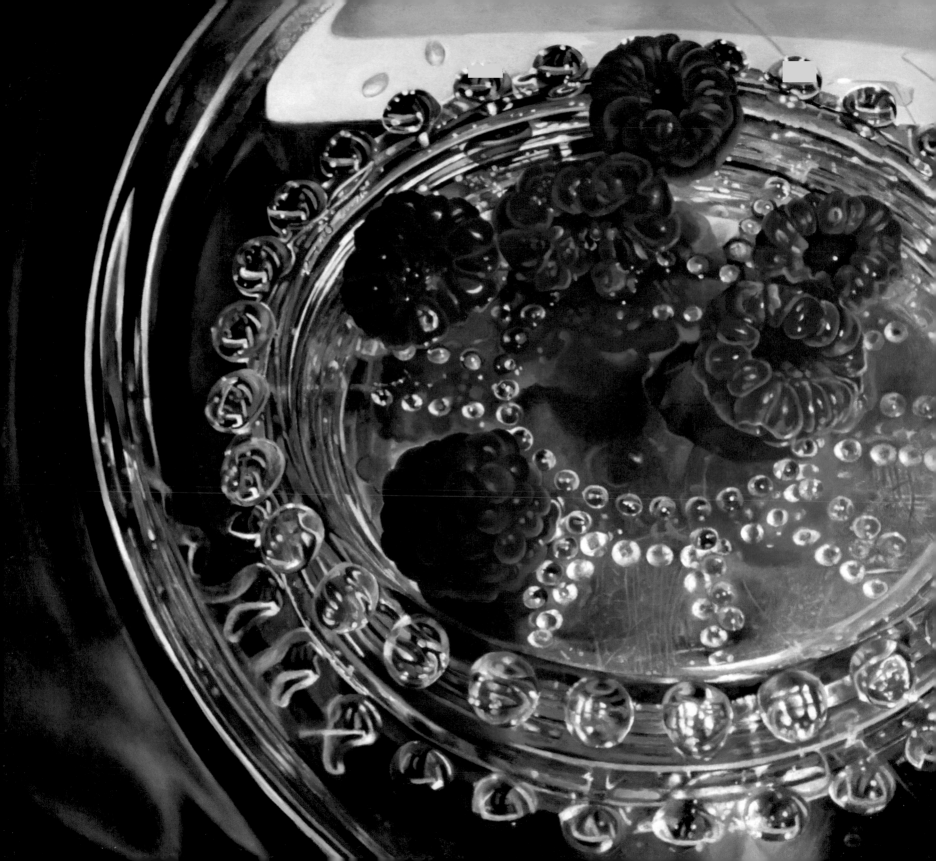

Raspberries Reflecting Summer (detail), 2000
oil on canvas
61.0 x 91.4 cm

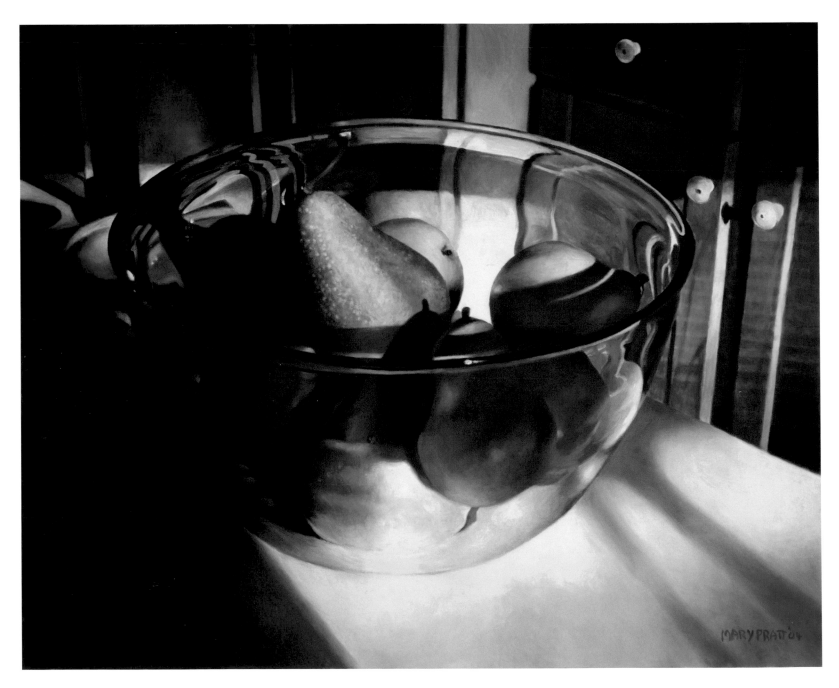

A Brighter Balance, 2004
oil on canvas
61.0 x 76.2 cm

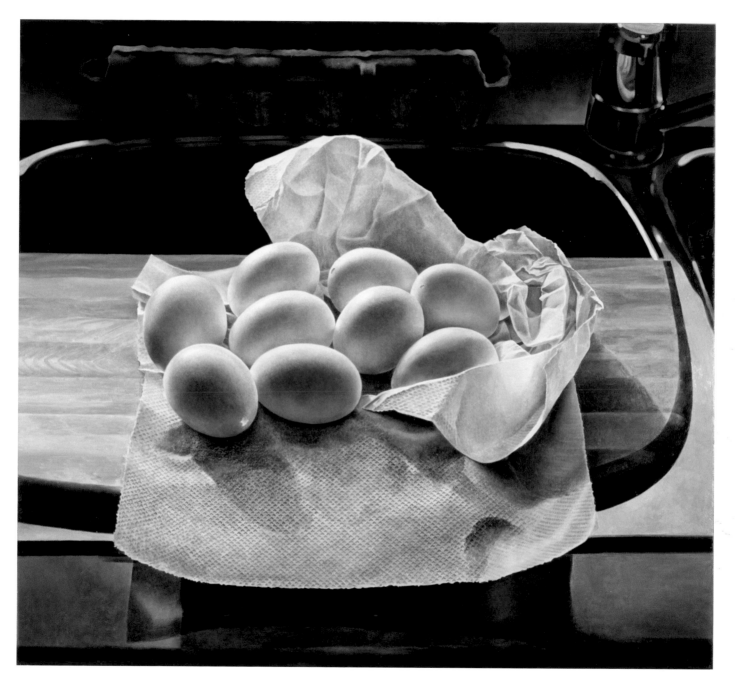

Hollowed Eggs for Easter, 1983
oil and gesso on Masonite
76.2 x 91.4 cm

facing page:
Pheasant with Lace and Velvet, 1990
mixed media on paper
161.3 x 119.4 cm

below:
Dinner for One, 1994
oil on canvas
61.0 x 91.4 cm

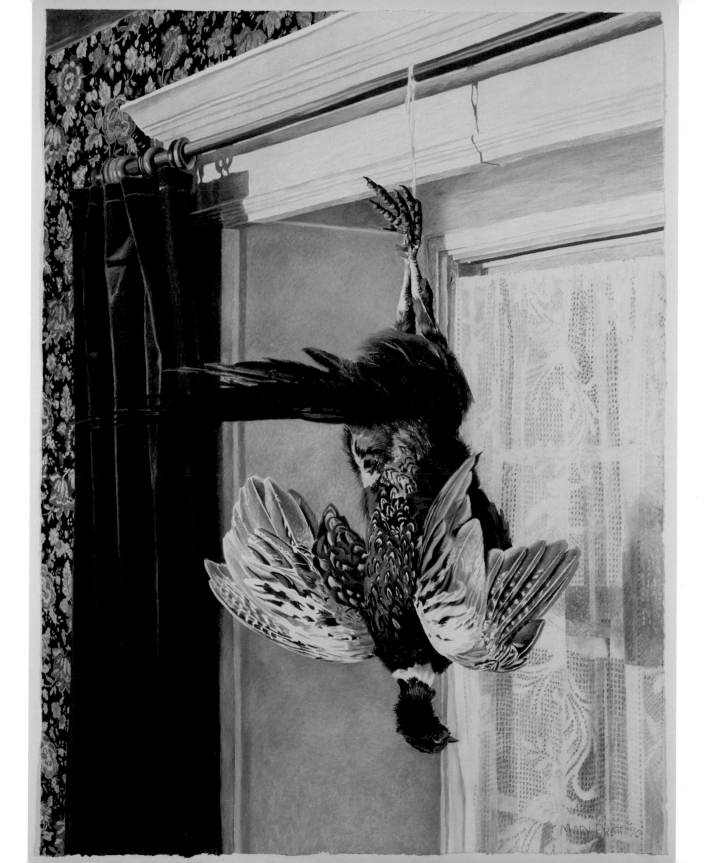

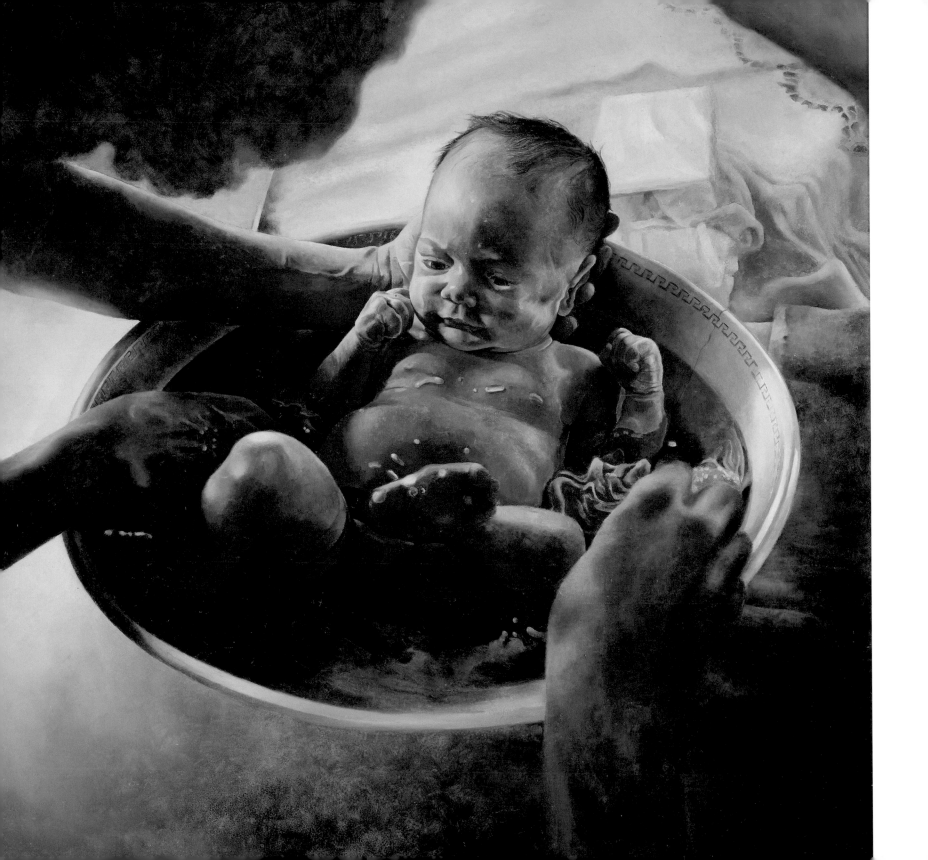

A Woman's Life

SARAH MILROY

IT SEEMS TO ME that women's psyches are like nesting dolls, hosting within them the histories of all the women who came before them. Open a woman and you find her mother — either as inspiration or as cautionary tale or, as is the case with Mary Pratt, both. Dig deeper and you will find her grandmother, or her great-grandmother, figures who leave behind them a somewhat fainter psychic imprint.

Mary Pratt comes from a long line of women of substance. I would call her a feminist, though the term may seem incongruous. She has devoted herself to picturing the domestic realm, an arena in which she has found meaning and a kind of sacred force. Fresh from art school, she chose early marriage to a man she found fascinating ("He was always more fascinating than nice," she says today — Mary and Christopher Pratt split in 1990) and motherhood of the old-fashioned, hands-on variety, and she has produced a body of work that searches for the truth of that experience. It's the view from the kitchen counter that she has brought vividly to life. The rubber gloves lie just beyond the picture frame.

Visit her today in her modernist saltbox house on Waterford Bridge Road, not far from downtown St. John's, and you find a woman happily ensconced in her domestic realm. Greeting me at the door, she is dressed in a blouse and loose skirt and a flowing mauve-grey sweater onto which she has pinned a small childhood photograph of herself with her mother, which she has turned into a little gold-rimmed brooch. Now in her late seventies, with her frothy silver curls and wire-rimmed glasses, she is a woman who can make orthopaedic shoes look fashionable. I am taking notes.

Child with Two Adults, 1983
oil on Masonite
53.7 x 53.7 cm

The place is full of books and magazines and art. A rampant fig tree threatens to engulf the living room, and works of art by her two artist children, Ned (a photographer) and Barb (a painter), are on the walls. A meticulous childhood drawing of a weasel by her lawyer son, John, winks from the kitchen wall beyond, along with photographs of her two daughters, Barb and Anne (a communications manager), and her eleven grandchildren.

Mary Pratt's kitchen sink is scarlet red, as is the big funnel-shaped hood over the stove, which she had fabricated to her specifications by a local tinsmith. It makes of the kitchen a kind of domestic furnace room; we could be in the snug hold of a ship. Her own 1967 painting of a hotdog supper is hung here — the first painting she ever made from a slide. Right beside it, above the sink, hangs a tiny grey-on-grey watercolour of a sheep in a barn, a quiet but commanding punctuation point in this maelstrom of art and life — the only work in the house by Christopher.

"Isn't it sweet," she says, folding the tea towel on the countertop. "I think it's the best thing he's ever done."

Of course, one could interpret such a remark as a dig (the thing is the size of a postcard), but there are two points to be made. The first is that her affection for him is still palpable. The second is that she may be right. The painting is full of tender feeling.

Mary Pratt has done what she wanted with her life, and she has the paintings to show for it. These have become beloved works of Canadian art, but it has long seemed to me that they have been embraced for the wrong reasons. Audiences have understood them as emblematic of the quiet steady lives of women tending to their families in blissful semi-rural seclusion. But these paintings often carry an undercurrent of darker emotions.

I had come to St. John's to ask about her art, about the women in her family, of whom I had heard so little over the years, and to explore her own relationship to femininity, which seems sometimes rapturous (woman as life force, nurturer) and sometimes troubled (woman as sacrifice, captive). In her paintings of dismembered chickens and cod fillets, I had read intimations that a certain violence underlay the smooth surface of family life.

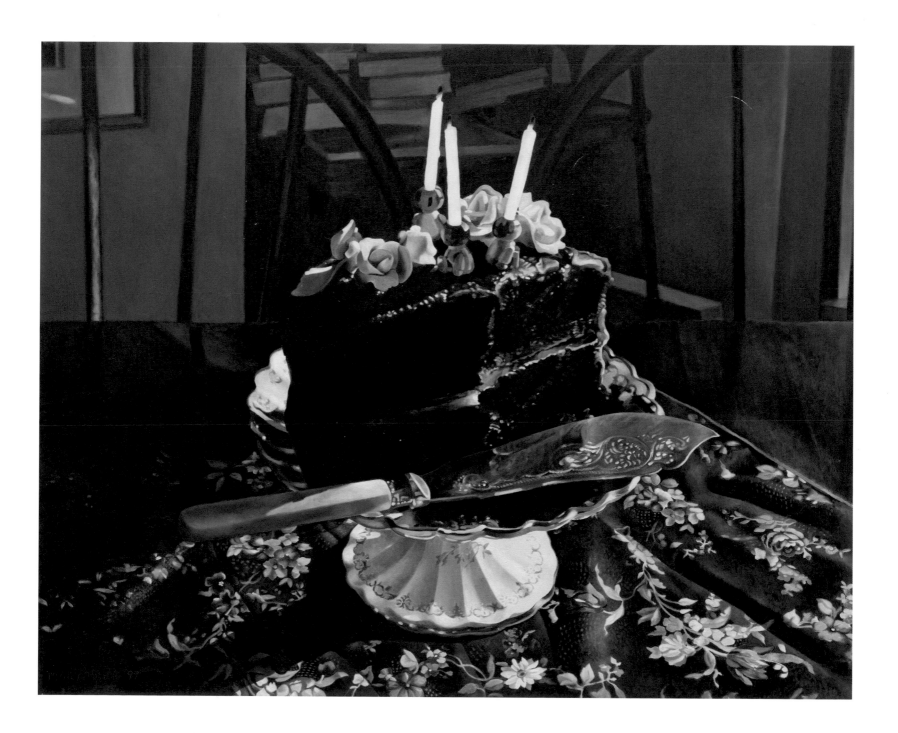

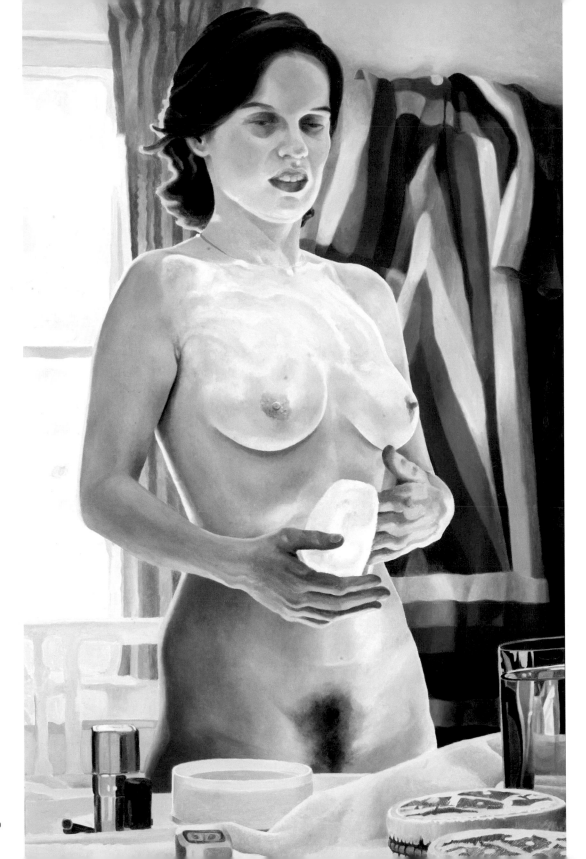

Cold Cream, 1983
pencil and oil on Masonite
48.3 x 41.3 cm

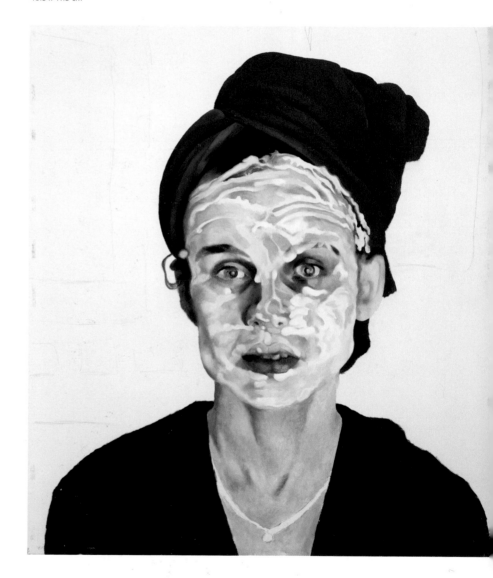

Then there are the paintings of Donna, a local model shared by Mary and Christopher in the late 1960s and early '70s, during their glory days at Salmonier. On canvas, Donna emanates a brooding solidity, standing half-naked in one of Mary's housecoats (Christopher took the source photograph at Mary's behest), lying on her side in bed (Christopher again) or staring out at the viewer, her face slathered in cold cream, her expression neutral (Mary took this one). In the Donna paintings, Pratt contemplates an intractable, almost brutal female force, describing in paint the creases left on her flesh by her blue jeans or the tight elastic of her knee socks. Donna is naked, not nude. How to reconcile these blunt encounters with the brimming jelly jars and fruit bowls?

Sitting with Pratt at her kitchen table, we look through the images for the work in this exhibition. Again and again we touch on questions of feminism. "I hate Judy Chicago," she says to me. "All those vulvas. I mean, we've all got them. So what." Instead, she has sought to embody female experience on her own terms. In one painting, from 1977, a deliciously charred hunk of roast beef sits cooling on a roasting

facing page:
Donna with Powder Puff, 1986
oil on Masonite
55.9 x 34.9 cm

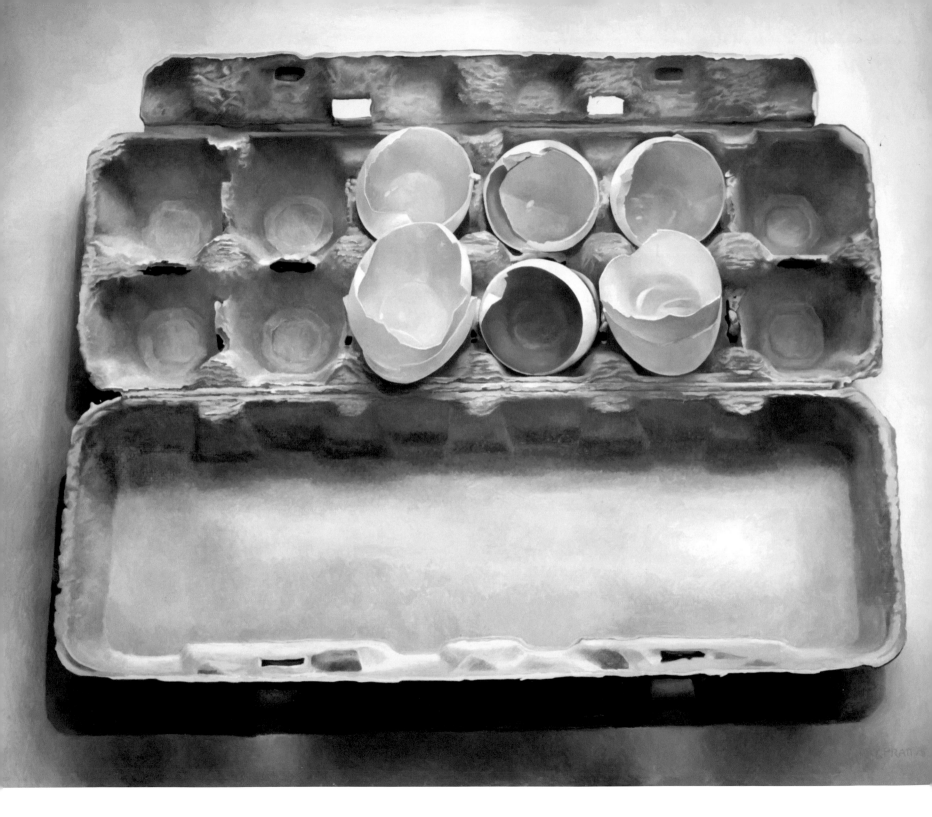

Eggs in an Egg Crate, 1975
oil on Masonite
50.8 x 61.0 cm

pan. "It is quite a sexy thing," she says to me, "with that sort of drool coming out of it. I can remember when I first showed that in a gallery, I heard a woman say, 'Well, I guess she can paint, but do you think she can cook?'"

At times the blind spots have been her own. In her 1975 painting of eggshells in a cardboard container, Pratt delivers a study in light and translucency, but that's not all. The picture, she says, was made in the aftermath of the death of her one-day-old son, David, and the twin that had died a few weeks earlier inside her. David would have been their youngest child.

"I showed this painting to a friend, and she pointed out to me that the eggs were empty," she says. "I had not noticed that, but of course it makes sense." She then tells me the story of the only time she ever saw her mother in tears: her father had brought her home from the hospital following what was likely a miscarriage. "I can remember like it was yesterday, seeing him carrying mother up this great big staircase, and she was crying. I must have been about two at the time. You never forget a thing like that." Such sorrows were kept close, but a painting like this tills the soil of

the soul, for painter and viewer alike. This is an image of fertility spent, an ethereal lamentation.

Sifting through the images, I notice how often her work depicts objects wrapped or unwrapped, or things being opened up — a piece of cake cut from the whole, a split pomegranate, a filleted fish, a bed with its linens and blankets spilling in the morning light, even an oil barrel disgorging flame in a make-shift bonfire. What has been contained becomes expressed — the opposite, I note, of Christopher's impermeable surfaces. "That's what women do," she says: they wrap things up, or unwrap them, or cut them open, or chop them, to ready them for the oven. Listening to her, I think about how a woman's body, too, is subject to episodic opening — from sexual intercourse to childbirth.

Mary Pratt's own life is a thing worth unpacking. Together we sit and examine the contents. "I'm afraid I had what you'd call an ideal family," she says brightly, dismissing my generation's craze for psychological self-examination. "I'm part of the old way, where people don't make such a big deal out of bad things." But her tales, as they unfold, seem vexed.

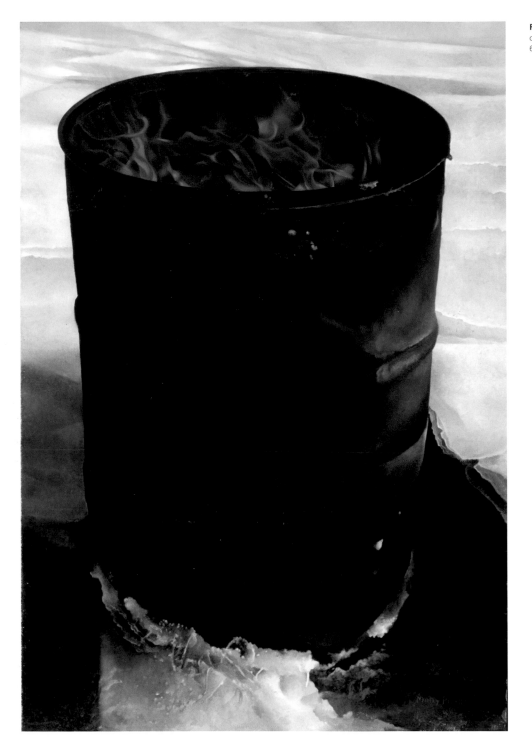

Fire Barrel, 1981
oil on Masonite
66.0 x 45.7 cm

facing page:
Roast Beef, 1977
oil on Masonite
41.9 x 57.2 cm

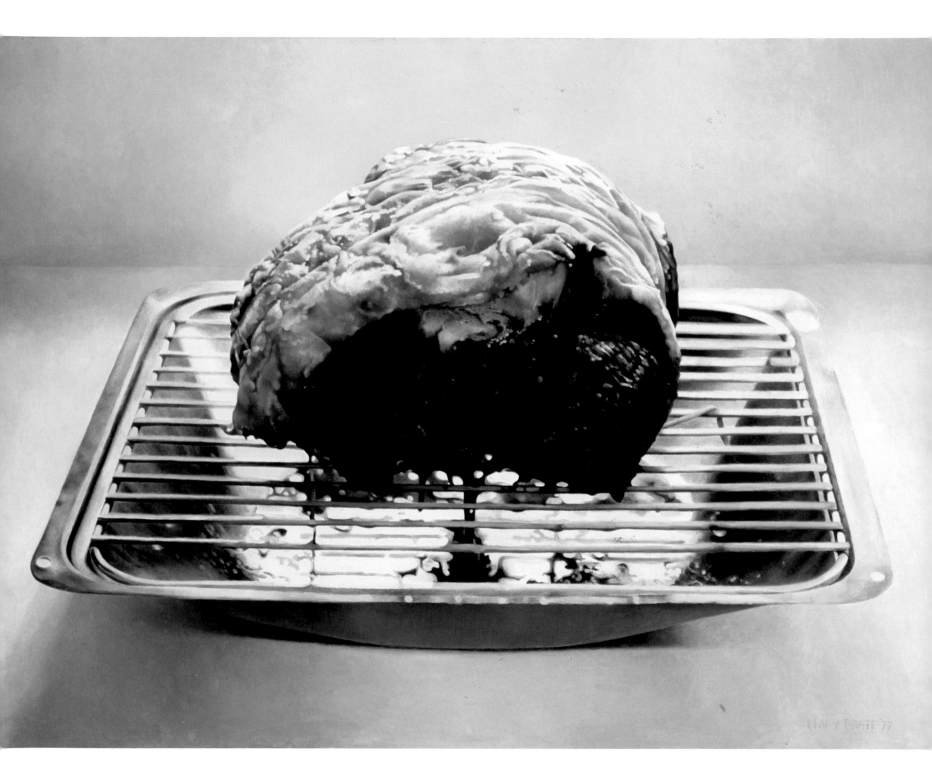

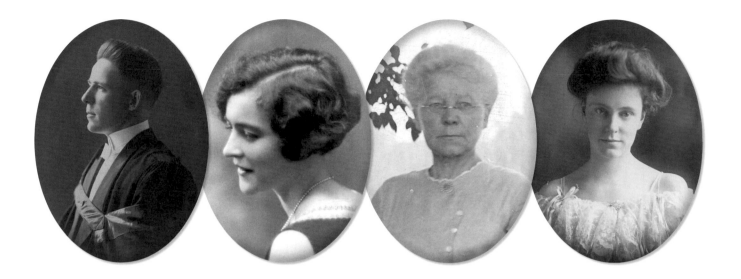

Our conversation first drifts to her father, now long dead. In his prime, he was an estimable figure: a high-spirited and plain-spoken Fredericton lawyer ("They called him Honest Bill West," she says), later the attorney general of New Brunswick, a Conservative member of the provincial legislature and a judge who served for a spell as deputy premier of the province. She adored him, but the stories she weaves about him carry the odd dark thread.

She tells me about the day he took her with him to a girly show in Fredericton. She was just six. "He and Mr. Smith from next door. There they were — my father, an aspiring politician and a lawyer, and all the farmers with their straw hats on, all of them just standing there, staring. When the woman finally decided to get undressed they put a screen up," she recalls, "but you could see her silhouette."

Her father encouraged her to be herself, she says, delighting in her strong character, yet there were mixed signals. When she was offered a spot to study art at Mount Allison University, for example, he said: "You go ahead over there. You'll probably be married by the time you graduate and if not, I'll buy you contact lenses." Finding a husband was job number one.

In her circle of family and friends, the women were strong, but their men often put them through the wringer. "The history of women in my family," Pratt says, "is the history of women who had to go it alone, who had to take life and fight for it." Her great-grandmother, Mary Margaret Coburn, ended her days living by herself in a single room in Fredericton, selling newspapers and magazines — self-reliant after the breakup from her boozing doctor husband, who

ran off with a local maid. "Her people were from Philadelphia; they were related to the family of the British aristocrat Lady Jane Grey. The only thing I have left from Mary Margaret Coburn is her recipe for fruitcake," Pratt says. "It's the most expensive fruitcake recipe that I have, there's so much brandy in it, you see, so I know it had to be a good one because she didn't have any money to spare by that time. And it was."

Mary Margaret's oldest daughter, Kate Edna, was Pratt's maternal grandmother and "the most beautiful woman in Fredericton." An intelligent girl, she dropped out of school when her parents divorced and was soon sent off to Philadelphia to break off a romantic alliance with a Catholic boy in Fredericton, though she met up with him again on the boat ride home. Ultimately, though, Kate Edna married Pratt's grandfather, a dentist who developed a thing for morphine and alcohol. After her grandmother's death, Pratt discovered a picture of the former beau tucked in the back of one of Kate Edna's picture frames, hidden behind a photograph of her grandfather.

Pratt's mother, Kate Edna's daughter, was named Katherine Eleanor McMurray. She was a tomboy, fond of fishing, swimming and riding horses at her friends' farms, and she loved exploring the countryside with her best friend, Marg Perry, a woman who went on to be a photographer for the National Film Board of Canada. The two were intrepid.

As she grew into womanhood, however, a sense of constraint set in. "She absolutely refused to be herself," Pratt remembers. "I mean it." While her father drank, Katherine became an early contributor to the household budget, making extra cash with her unending batches of divinity fudge — a white concoction of sugar syrup and beaten egg white. "There was no fooling around with my mother," Pratt remembers. Industriousness was a cardinal virtue.

After secretarial training in high school, she went to work as a stenographer in a Fredericton law office. At twenty-three she married Bill West, a lawyer eighteen years her senior. But marrying a man better educated than herself soon left her feeling awkward in Fredericton society, and she withdrew to more solitary pursuits. "She put away her riding boots and put on her little hats and veils," Pratt remembers. "She

tried to become a lawyer's wife." In the summertime, though, she would take her two girls out to the Bay of Fundy to be near the sea. "She was always trying to get to the country."

At home Pratt remembers her mother's meticulous cookery, in particular the luminous jellies she made — signals, perhaps, of some private joy. "Oh they were gorgeous," Pratt remembers. "By then we were living in a fieldstone house with deep sills, and she would arrange them along the window ledge — they were west-facing windows with the light coming through — red currant jelly, highbush cranberry jelly, raspberry jelly, blackberry jelly — all as clear as glass." Her mother would turn them onto a cut-glass dish, and in that short distance between the kitchen and the dining room they would quiver, holding the light. "It's something you don't forget," Pratt says. "You can see how fortunate I was. It was up to me to do something with it."

No doubt inspired by this, Pratt used to arrange full water glasses tinged with watercolours along the sill of her bedroom window. Her mother allowed it, but she insisted that her daughter keep the bedroom door shut. "That way no one would see and think I was *peculiar*. That's the word she used," Pratt remembers. "*Peculiar*." It would be their secret.

Her mother also read and played the piano, and she took up the hobby of hand-tinting photographs. Pratt and her sister, Barb, would spend hours helping her with it, rubbing little dabs of pigment into the paper with linseed oil. "She taught us how to look at things," Pratt says. "She would say, 'Now look at that grass. This is the colour you think grass is,' holding up a tube of green pigment, 'but if you look down in the garden, do you see this colour? No. What you see is lines of pink, lines of yellow.' I moved into doing it, just because my mother enjoyed it." When Pratt was accepted into art school, though, her mother put her own paints away. She never touched them again.

Happily, the West family firmament included other, less conflicted female stars. There was Cousin Jean, a singer who threw up at her Juilliard audition but still made it all the way to *The Ed Sullivan Show*. ("She had dark red hair," Pratt remembers, "and she used to talk to me about her love affairs. She once told me that her hair had gone straight because her boy-

left to right:
Katherine Eleanor (McMurray) West, Mary's mother
Hon. W.J. West, Mary's father

friend didn't love her.") There was Auntie Marjorie, her father's sister-in-law. "She used to talk to me about books, and she looked after the children's library in Sackville," Pratt remembers. "Whenever she saw me coming she would say — 'Now *there's* someone worth talking to.'" The local librarian, Louise Hill, also kept her in ample literary supply, guiding her through the canon from A to Z. And there was Miss Buloff from down the street, with her cats, an eccentric "who wore a long velvet dress under her apron and a little purple velvet hat. I don't think she ever changed them. I think she went to bed in them."

Pratt seems to have taken the best from them all — the intellectual curiosity, the sense of family ritual, the industriousness, the taste for eccentricity and the ability to understand her life as a kind of adventure. She has been painting, she says, since

she was eight, often outdoors on her own, under her mother's cautious eye. "I think my mother thought anything too wonderful, anything too beautiful, and I would fall apart," she recalls today. "She knew I was not like the other kids. She wouldn't teach me to do embroidery because she thought I was too sensitive." Pleasure was meted out in thin slices.

An outsider by temperament and, by her telling, unpopular with the other girls, Pratt nonetheless was often chosen for leadership roles at school. "I think it was because I had a sensible face," she says today. At eighteen she made her way to art school, marrying soon after graduation.

The babies came quickly, but their childhoods were not ordered by the customary round of lessons and clubs. Instead they ran wild on the banks of the Salmonier River, and they loved it. Christopher took

an active role in it all. "Lots of kids came to play," Pratt remembers. "They liked to come to our house." In the role of self-appointed troop leader, she got her girls and their friends berets and neckerchiefs to wear. Together they made scrapbooks, found an Indian pipe in the woods, hunted for chanterelles. "I taught them first aid," she says. "We learned how to wash a baby. I taught them everything I thought a girl might like to know. Of course, my own kids goofed off. They thought it was embarrassing."

The paintings from these years reflect her immersion in the rhythms and rituals of family life. Two chickens in a roasting pan, prepared for the oven; a silver trout laid out on plastic wrap (a study in reflection and translucency); the slab of sirloin readied for the flame — these images anticipate the pleasures of sitting down together and communing, in the way that families do. Domestic work, as recorded here, is a gesture of love toward all who partake, but it also has a certain propitiatory quality. "There is no celebration without a sacrifice," Pratt says to me. "You can't have something without giving up something else. That is one thing I have learned in life."

Through the 1980s her marriage to Christopher became difficult. "He got jealous whenever anything happened for me," she says, referring to the years when her painting career was finally building. "I guess I shouldn't be surprised by that, but I was. He and I had always developed together."

I find myself wondering if the Donna paintings aren't in fact paintings of Pratt herself, embodying aspects of her own drive and sexuality, temporarily thwarted. (The two women remain friends to this day.) We talk for a minute about *Girl in My Dressing Gown* (1981). Here, the oversized garment drapes over Donna's taut, semi-clad body, trailing on the floor, its texture incongruously flimsy against the model's sensible bra and briefs. I ask her what she thinks about when she looks at the picture. "I wish I had ironed the negligee," she says, with a quick laugh. Settling in to her recollections, though, she continues: "Donna had come to us at a disastrous time in her life," following a painful breakup. "Maybe she was angry at having her picture taken, maybe she was angry at men, maybe she was heartbroken, angry at life itself and the hand she had been dealt. She had come into our world, and

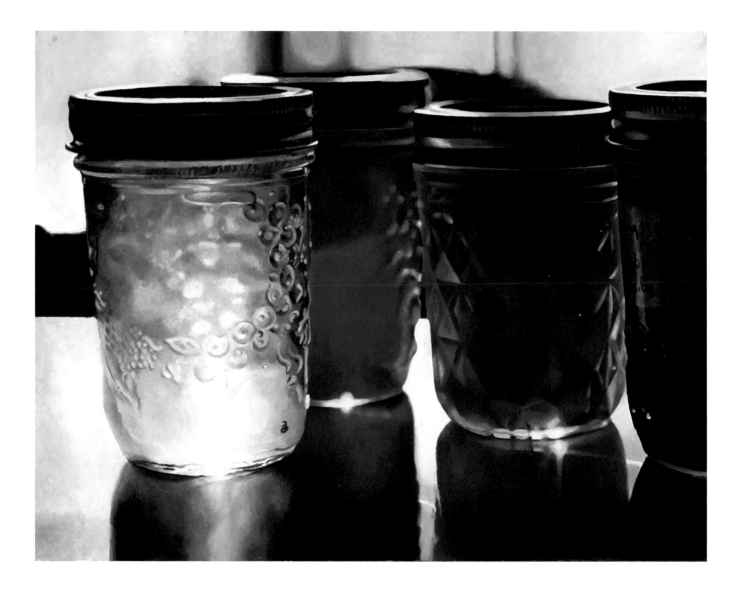

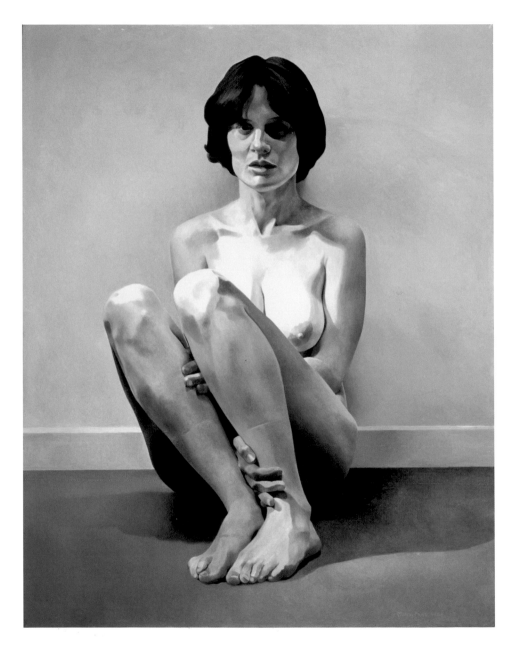

Donna, 1986
oil on Masonite
90.2 x 69.9 cm

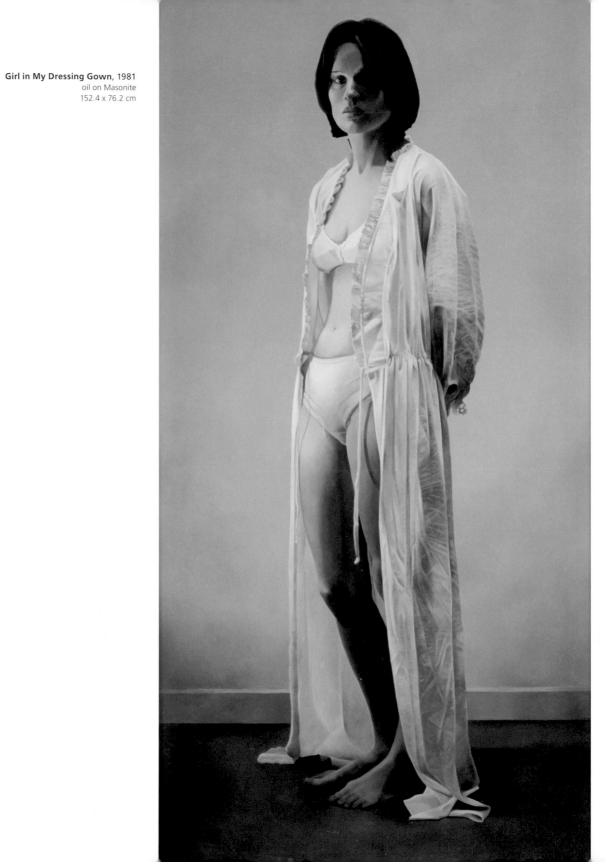

Girl in My Dressing Gown, 1981
oil on Masonite
152.4 x 76.2 cm

Barbara (West) Cross and Mary Pratt

it all looked so easy and wonderful, but she knew she still had to make a life for herself. Maybe that made her angry, too." Maybe she wasn't the only one.

Toward the end of our time together, we turn to the most violently charged painting Pratt has ever made: *Service Station* (1978). The picture shows a flayed moose carcass hoisted up on a truss on the back of a flatbed truck. The source photographs had been taken in the garage of her friend Ed Williams, in Salmonier, she says, but she held on to the images for five or six years. Finally, after some encouragement from National Gallery of Canada curator Mayo Graham — who discovered the images in a pile set to one side in her studio — Pratt set out to make the painting.

"We had lost the babies, then John got sick [her son had a brief skirmish with cancer], and I got through that, and then I said to myself: you can do this now. You know what this is about." The animal's long legs and hoofs, suggesting a woman's legs and feet, give the painting an air of ritual sacrifice. "I had to change the colour of the walls," she says. "They were hospital green. It was too much."

She made the painting, but before she sent it off for sale, she asked Ed Williams to come and see it. "I will never forget it," she says with a laugh. "He stood there in my studio looking at it for a moment, and then he shook his head and said, 'Well, well. There's my old truck.'" ∎

POSTSCRIPT

My long interest in Mary Pratt's painting began at the side of my own mother, Elizabeth Nichol, who was her art dealer in Vancouver for many years. While visiting with Pratt to research this essay, I learned that my mother had been instrumental in arranging a haven for her after the separation from Christopher, organizing a condo in Vancouver and inviting her to come west for a while and take a break. "I am very grateful to Liz Nichol," Pratt wrote in her book *A Personal Calligraphy*, recalling this pivotal transition in her life. "She did, after all, set it up." This was an act of sisterhood unknown to me. Going to St. John's to learn about Pratt's life, I ended up learning something about my own. This essay is dedicated to the memory of my mother.

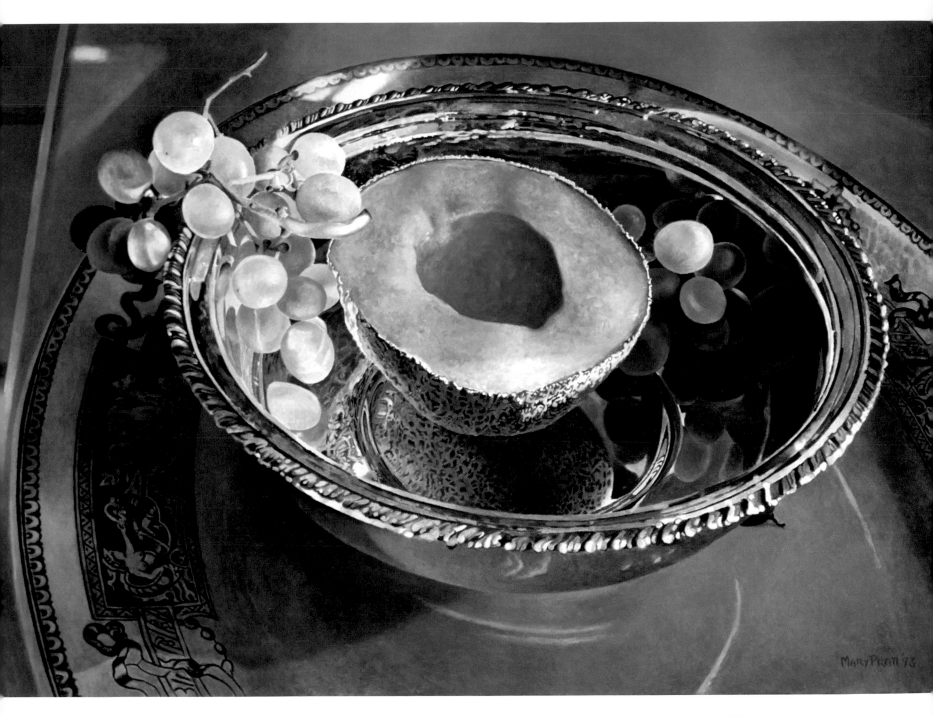

**Green Grapes and Wedding Presents
with Half a Cantaloupe** (detail), 1993

oil on canvas
61.0 x 91.4 cm

Barby in the Dress She Made Herself, 1986
oil on Masonite
90.8 x 60.3 cm

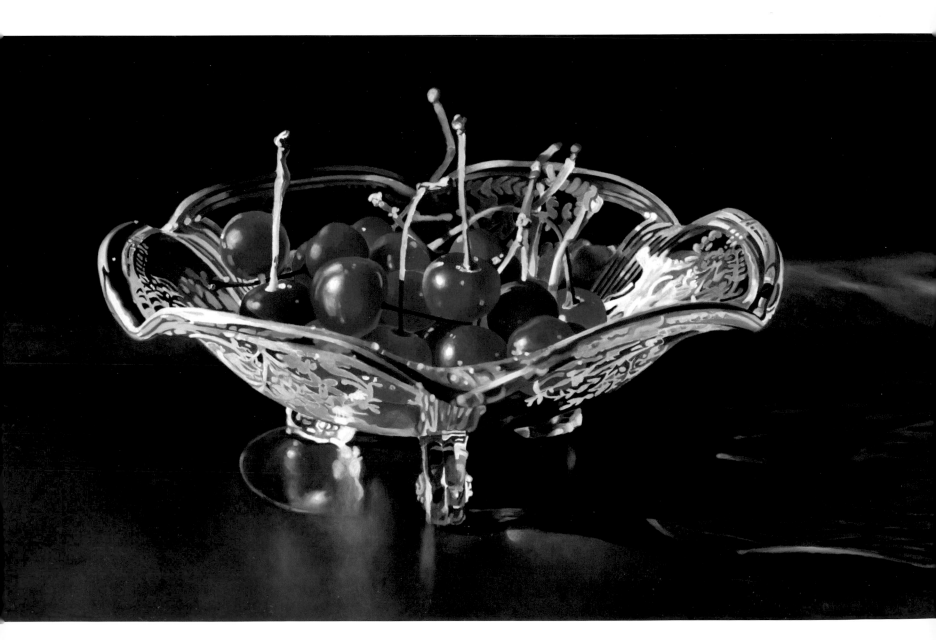

Cherries, 1998
oil on Masonite
33.0 x 55.9 cm

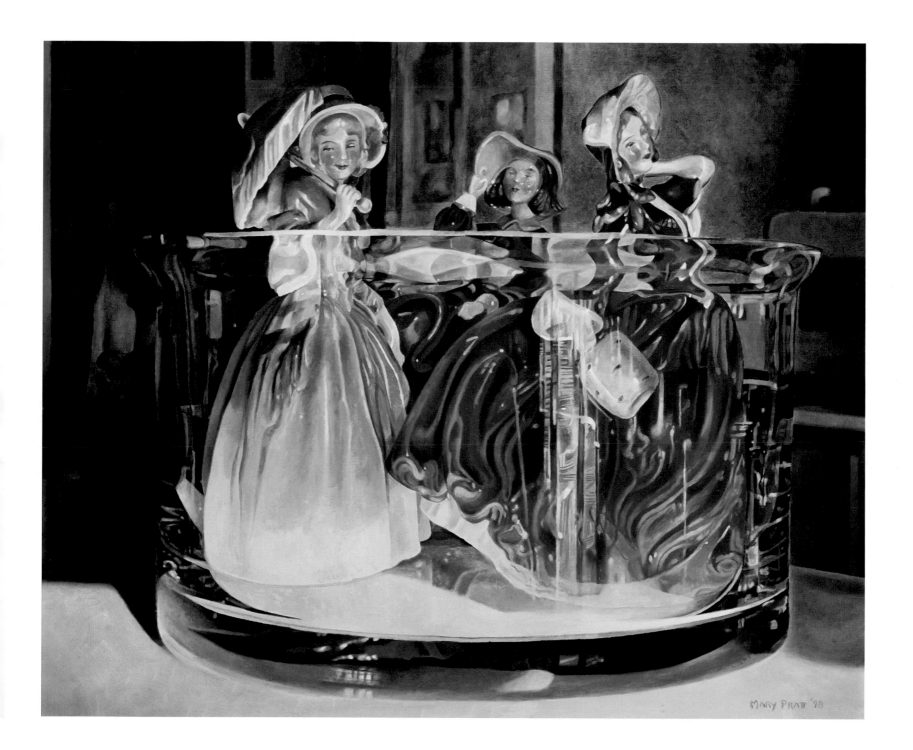

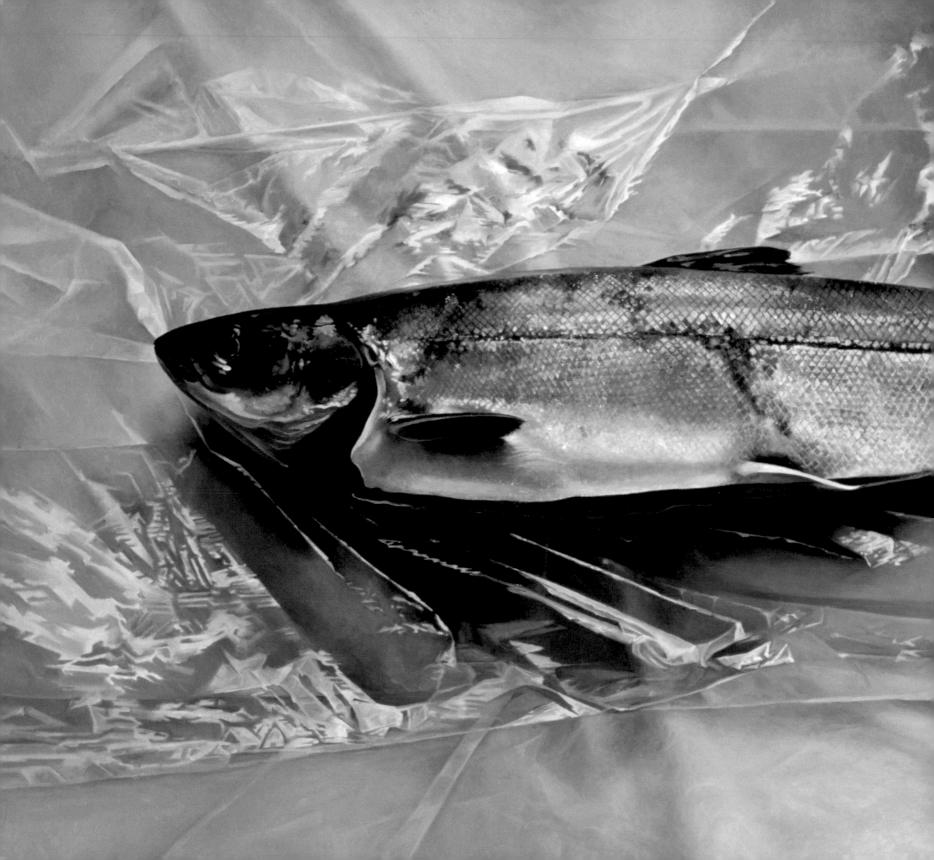

Salmon on Saran, 1974
oil on Masonite
45.7 x 76.2 cm

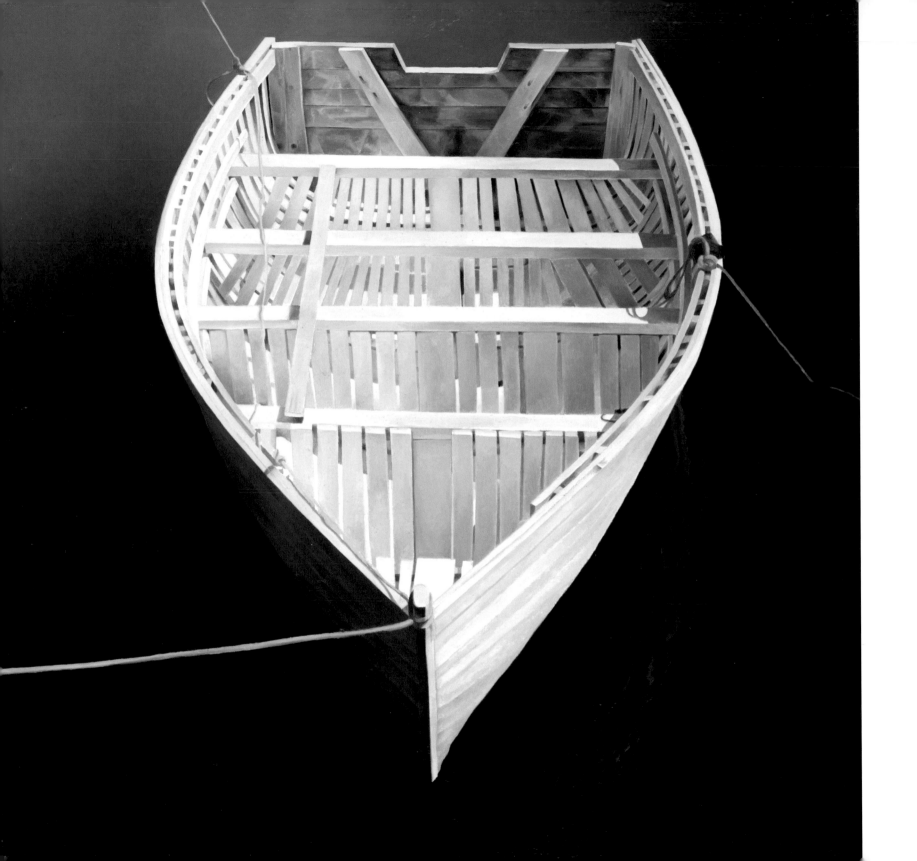

Base, Place, Location and the Early Paintings

CATHARINE M. MASTIN

CONTEMPORARY ARTISTS often describe themselves as "based" in a particular location — for example, "Toronto-based artist" and "Vancouver-based artist."[1] To self-identify with a location in which an artist has anchored the development of, and public access to, her or his art practice is clearly advantageous or why make the point? But some artists work in cities that are not known as art centres or live in rural or remote locations and do not self-identify in this manner.

Mary Pratt has been associated with three locations during her celebrated career as a prominent Canadian painter — her birthplace in Fredericton, New Brunswick, and her two long-term Newfoundland residences, in St. John's and St. Catherine's (located on the Salmonier River near St. Mary's Bay). However, nowhere on her curriculum vitae does she identify with a place. Even so, place is a recurring theme throughout Pratt's early artwork. We may ask, then, how Mary Pratt identified with location in the context of her art practice.

Although the phrase "based in" was not commonly used by artists of Pratt's generation, her creative identity has been closely associated with New Brunswick and Newfoundland. Mary Pratt's life as artist, mother and marriage companion to High Realist painter Christopher Pratt deeply affected how she articulated her relationship to place. To establish how Pratt identified with place, it is important to highlight her family background and marriage and then analyze several early paintings that illuminate that history — specifically, of being "based in" St. Catherine's, Newfoundland, beginning in 1963.[2]

. . .

Tied Boat, 1980
oil on Masonite
45.7 x 45.7 cm

"A Canada-Newfoundland Marriage"

When Mary West of Fredericton and Christopher Pratt of St. John's married on September 12, 1957, in Fredericton, their union marked the beginning of what she later described as her "Canada-Newfoundland marriage."[3] They had been courting for two years after first meeting at Mount Allison University in Sackville, New Brunswick, where they were both students — Christopher focusing on pre-med courses, and Mary in the fine arts program. Throughout her earlier education, Mary had been an exceptional student, winning the unwavering confidence of her teachers; she was well positioned for university life and had the capacity to pursue virtually any profession.[4] Her peers remarked: "We may be sure she will be a success in whatever field she chooses."[5]

Mary West was raised in a well-to-do family by her parents, Katherine Eleanor McMurray and William John West. She valued both parents, but her father commanded a special place in her life, for he was a highly visible professional in his role as attorney general for the province of New Brunswick.[6] She recalled, "I thought Dad knew God…In fact, I was sure that he did…He seemed to almost laugh his way through life."[7] From her father's example, Mary West learned the importance of professional respect, and this legacy fostered her strong ties to her hometown and province. In her "Canada-Newfoundland marriage," Fredericton and New Brunswick were her Canada.

Christopher Pratt held equally strong ties to his family history in Newfoundland. Members of his mother's family, the Dawes, were among the first European settlers to arrive on the shores of Newfoundland, so family lore contends; on his father's side, his great-grandmother settled in Newfoundland in the 1700s. Christopher was mentored by his paternal grandfather, James C. Pratt, in both business and painting, and in St. John's he attended Holloway School and Prince of Wales Collegiate. His uncle E.J. Pratt was a noted Canadian poet, and his father was a prominent Newfoundland businessman. The Pratt family was wholly dedicated to Newfoundland culture. To them, the island was a separate nation: they had been anti-Confederates in the years leading up to Newfoundland's union with Canada in 1949.

When asked by one of his instructors at Mount Allison, "What is [sic] you?" Christopher replied, "I is [sic] a Newfoundlander."[8] Mary and Christopher held strong allegiances to their respective home provinces, and these differences became serious considerations in their married future together. As Mary recalled, "Christopher's dedication to his country came first in those days."[9]

When Mary and Christopher settled in St. John's, the decision to be in Newfoundland was permanent and clearly privileged his family history. It was not the first time she had lived there to support their ongoing relationship. Much to the chagrin of her parents, at twenty-one Mary went to St. John's to work as an occupational therapist and teacher.[10] Her first experience there underlined sharp contrasts between Fredericton and Newfoundland manners and customs: "The harsh, abrupt opinions of Newfoundland astonished me...I had been raised in an order I accepted and admired...I loved and wanted to be like my relatives."[11]

In 1963, after Christopher resigned from his position as curator at Memorial University Art Gallery for health reasons, the Pratts moved their young family to his father's summer cottage. There they lived rent-free, and Christopher could concentrate on painting full-time and have his own studio.[12] In 1981, Mary reflected on this move to "Salmonier" (as their home was informally known). She recalled that it was "like moving from one country to another [and to] a strange land," where she was asked to "make a home in someone else's house" and where she felt like "a foreigner."[13]

Mary Pratt fulfilled her parents' expectation that she would marry, and so, she recalled, "they didn't mind my art because I was a girl."[14] In the Salmonier years, she learned quickly the challenges involved in sustaining the two identities of artist and companion, knowing that "life as a creative person is not always comfortable [and] no one expected to make a living out of art in 1961."[15] Her commitment to being an artist, though, dates back years before she first met Christopher.[16] Between 1947 and 1952, Mary had taken classes with various instructors at the University of New Brunswick Art Centre.[17] She chose to pursue post-secondary studies in the fall of 1953, and guided

by her father, she headed for his alma mater — Mount Allison University.[18] With Lawren P. Harris, Ted Pulford and Alex Colville teaching there, Mary was ensured excellent instruction.[19] Her experience at Mount Allison was, however, deeply gendered and tested the limits of how she juggled the identities "artist" and "wife" — later adding "mother" — in post-war Atlantic Canada where, as elsewhere, breadwinner-homemaker ideology persisted in shaping men's and women's gender roles within a marriage.

Midway through her studies, after the birth of two children, a meeting with Lawren P. Harris yielded this recommendation: "You know that if two artists are married, only one is going to be successful. And in your family, it's going to be Christopher. So why don't you just understand that and look after the house and the children?"[20] Pratt retreated home that day in tears but has said she held no personal ill will toward Harris. She recalled the discussion to have been an important moment,[21] and as author Tom Smart observed, she then "took hold of her life and chose to continue painting and arrange her responsibilities as a parent around her needs as an artist."[22] Henceforth, though, Mary yielded decision making about their place of residence to Christopher, and it was not until all four children were in school that she consistently found time to work on her art.

In these years, when access to birth control was limited and health risks related to the postwar "pill" were significant,[23] the Pratt children arrived in quick succession.[24] At Salmonier, separated from her life in Fredericton, Mary began experiencing forms of geographical, political and social isolation she had not known before.[25] Her isolation was compounded by the fact that she did not learn to drive until well into mid-life. For more than two decades, then, she was dependent on Christopher and others if she was to have any contact beyond St. Mary's Bay. She was also isolated from other female artists.

. . .

Associating Place with Art Practice

Salmonier is located near a deep bay on the Avalon Peninsula's south coast.[26] For Christopher, the family's move there made for a continuum with his family history in Newfoundland, but for Mary it was a very different experience. She was without her family, had no work outside the home and no access to the sort of social life and urban community she had enjoyed in Fredericton. She and Christopher were now each other's near-exclusive support network and critic. It was in the context of these experiences that Pratt's early works were made; in Salmonier she came to terms with the role that place would play in her paintings.

She had been painting steadily since the early 1960s, and she received further momentum from curator Peter Bell's commitment to showcase her work at the Memorial University Art Gallery in 1967 and 1973.[27] Pratt's early works took as their subject her home and surroundings and included the paintings *The Back Porch* (1966) and *Cake, Apples and Potatoes* (1969). Between exhibitions she increasingly turned

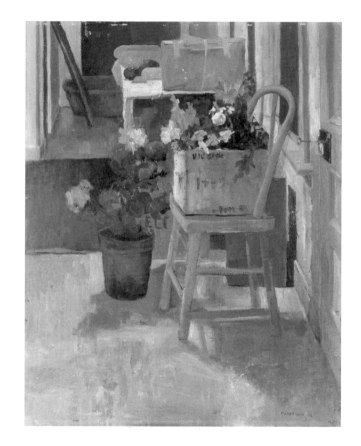

The Back Porch, 1966
oil on canvas board
50.8 x 40.6 cm
The Rooms Provincial Art Gallery,
Memorial University of Newfoundland Collection

97

Cake, Apples and Potatoes, 1969
oil on Masonite
82.5 x 52.1 cm

her attention toward household and kitchen subjects. These were, as art critic Lucy Lippard once observed, subjects embraced by many middle-class female artists because of their social and economic realities.[28] Pratt likewise recalled of her domestic imagery, "My strength is finding something where most people would find nothing."[29]

Supper Table (1969) was a critical painting illustrating Pratt's engagement with domestic interiors, and the artist has cherished it for its transitional significance.[30] The revelatory moment of her discovery of light has been repeated in writings on *Supper Table,* but interpretations of the painting's role in domestic politics and artist-couple marriage relations have been overlooked. The latter approach, however, enhances understanding of how the painting marked a crucial junction in Pratt's sense of her life in Newfoundland. Of this family supper table, Pratt recalled: "I asked Christopher to take the children for a while because I just had to paint it." Author and friend Sandra Gwyn elaborated: "Christopher thought she was crazy. The light would be gone before she even got her paints out. She persisted and started making drawings.

Christopher watched her, said nothing, left the room and came back with his camera. He took quick shots of the now fading light shining onto the remnants of the supper on the table. A month or so later he brought her the slides."[31]

Supper Table occasioned a fortuitous exchange between artists regarding the ephemeral specificity of that moment's lighting.[32] The painting is rich in references to popular culture: the hot dogs, condiment bottles and Staffordshire Chef Ware dinner service on the table.[33] There was also the ephemeral process of its making in artist-couple and family-life dynamics. Gwyn's account reveals that Mary never left the room (she kept sketching), but Christopher left to retrieve the camera, to preserve the light in a photograph. Other family members had left the scene.

Pratt would describe this "table of 1968" as "simple and honest, jumbled and untidy in its pool of light...indicative of us."[34] Pratt's postwar-era family table is a site of constant labour — to be set and reset, cleaned and recleaned, meal after meal — which all fell to Mary, with no foreseeable end. Clearing the table had been among those duties expected of

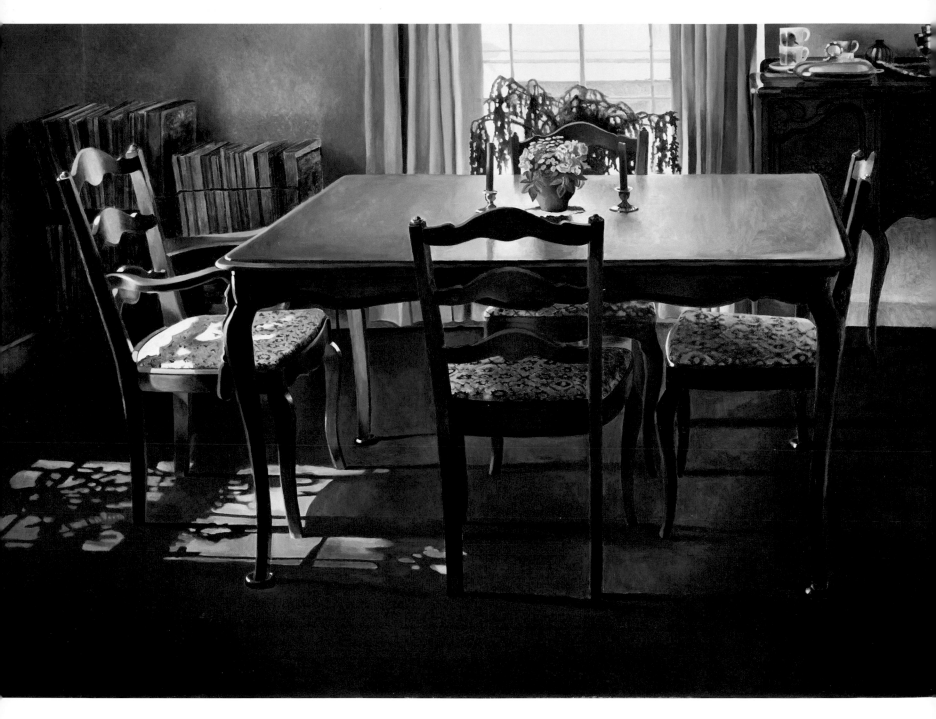

The Dining Room with a Red Rug, 1995
oil on linen
91.4 x 137.2 cm

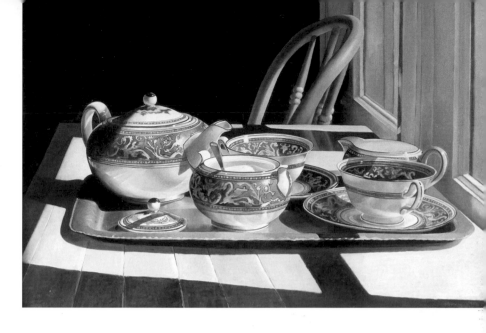

The Florentine (detail), 1971
oil on Masonite
30 x 40.6 cm
Private collection

female members of the West family household, and although Mary's mother had taught her to be efficient (she used clearing trays), Pratt recalled how much she disliked being left to the task, even with help from her children, while "Christopher meanwhile pushed back his chair and ambled off to watch the news."[35]

Pratt did not paint *Supper Table* as mere testimony to women's oppression: the making of this work established a voice from which she could speak as a female artist. She had identified the subject, scene and lighting, and in her role as interpreter of the slide image, she had the last word. When she painted the table she exposed the social politics that determined the gendering of rooms in Euro-Canadian households and family life. Indeed, *Supper Table* would not be the last of her dining room scenes that commented on gender roles in marriage, artist-couple relations and women's social isolation.[36]

Pratt painted many other subjects — such as raw meat and cooked food — to comment further on her relationship to place: these include close-up views of baked apples and red currant jelly. The works *Fredericton (Waterloo Row)* (1972) and *The Florentine*

(1971), however, underscore how she addressed what she came to understand as the division of her life between "her Canada" (Fredericton) and Christopher's Newfoundland. Throughout the Salmonier years, Pratt longed for contact with her family and found separation from them difficult.[37] Travel to Fredericton was infrequent because of the cost, and she corresponded with her family by letter.[38] *Fredericton (Waterloo Row)* depicts in stately proportion a house near the West family home. For Pratt, the scene recalled an idyllic childhood: "I am standing in the driveway of my father's house, looking down the street. The early morning sun is shining across the Saint John River, through the elm trees and onto the faces of the houses. It is so familiar to me, so inevitable, that I never imagine carpenters building these houses. I assume they have 'grown,'

Fredericton (Waterloo Row), 1972
oil on Masonite
76.2 x 116.8 cm

like the trees, and have always been there, and always will be there."[39]

The serenity of *Fredericton (Waterloo Row)* is echoed in *The Florentine,* depicting a porcelain tea service given to Mary and Christopher for their wedding. She remembered this service as another "visible reminder of the formality of her childhood," a marker of the distance between her and her family.[40] Contrasts between the West and Pratt family histories were consequential in this Canada-Newfoundland marriage. As Christopher reflected, "I always felt out of place in the West home, but never unwelcome. I didn't like the claustrophobia of Fredericton, if that's what it was. I did feel inferior, the causes and reasons were many and inadvertent. Mr. West believed that there should be learning in a house: art, music, literature, none of which had been priorities in our home."[41]

Mary Pratt's reflection on her past, as shown in the two paintings, was a sharp contrast to rural life in Salmonier, where hunting was part of the local culture and a means of survival for most families. She took up this subject in the painting *Dick Marrie's Moose* (1973),

depicting a moose carcass slung outside a neighbour's house. It was a scene Pratt identified as "the family's meat supply for the winter" and an "aggressive necessity" that, in mirror reflection against the house exterior, "hinted at a darker side to life."[42] Imagery of meat appears regularly in Pratt's oeuvre: *Eviscerated Chickens* (1971) depicts two carcasses sitting on a Coca-Cola box, which, Pratt observed, "symbolize much about life in this civilization."[43] Once, she followed her mother's practice of cleaning chickens: "I thereafter contented myself with frozen chickens," she said, never getting over the "barbarism of butchering."[44]

A comparison of the four works — *Dick Marrie's Moose, Eviscerated Chickens, Fredericton (Waterloo Row)* and *The Florentine* — effectively exposes Pratt's staging of the sex-gender identities she juggled as a female artist living in Salmonier. These included her two identities: Mary Pratt of Fredericton and Mary Pratt of Salmonier. The artist-daughter-wife-mother's lineage in British-Canadian traditions of civility in Fredericton, contrasted significantly with her married life in a coastal community where hunting and

Eviscerated Chickens, 1971
oil on Masonite
45.7 x 54.0 cm

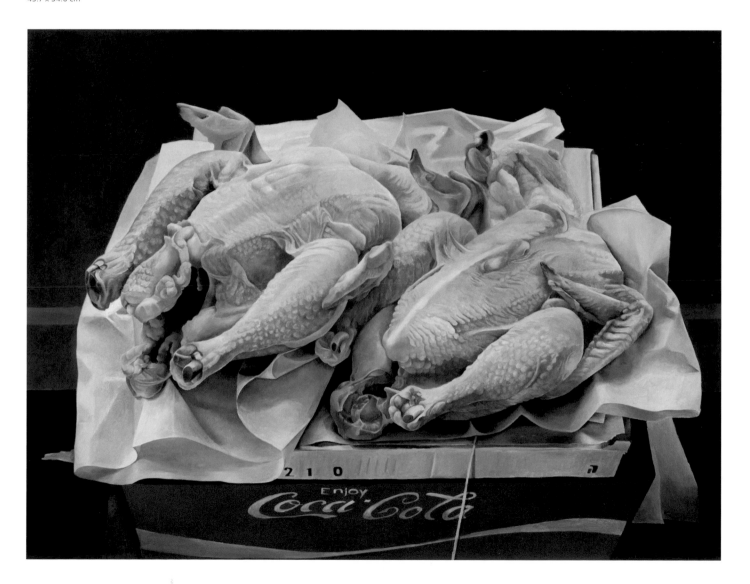

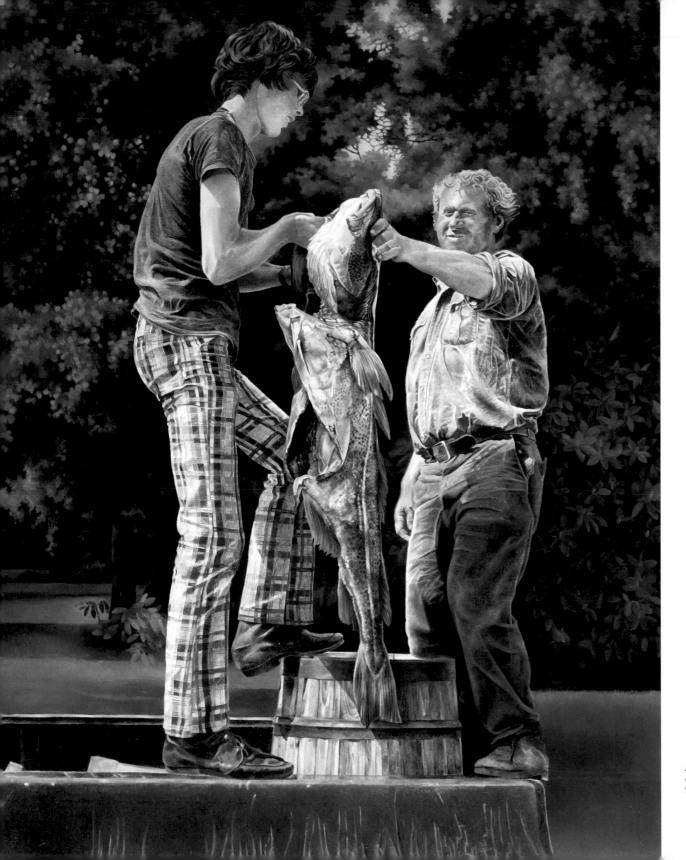

Another Province of Canada, 1978
oil on Masonite
91.4 x 69.8 cm

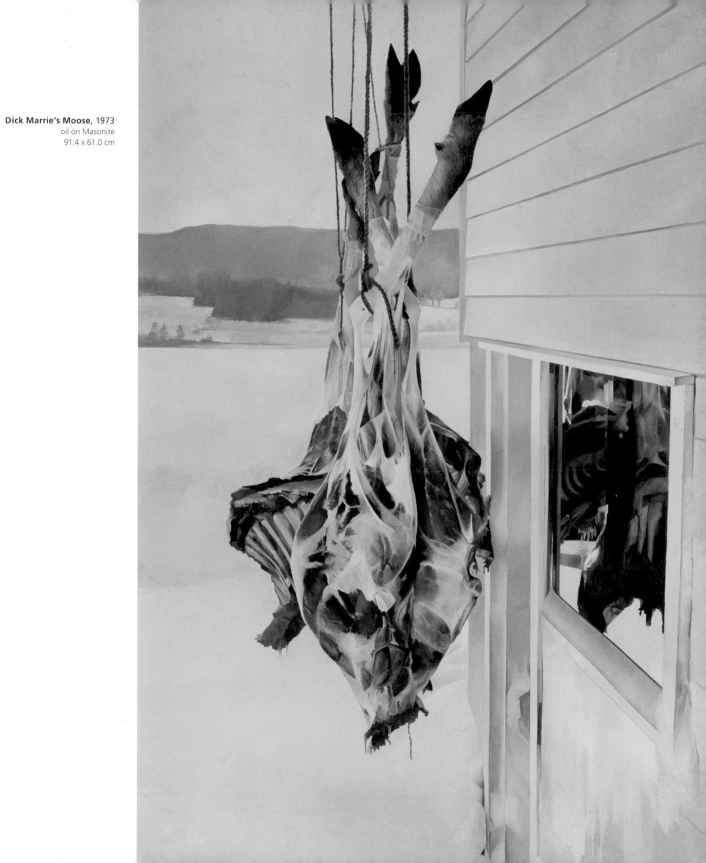

Dick Marrie's Moose, 1973
oil on Masonite
91.4 x 61.0 cm

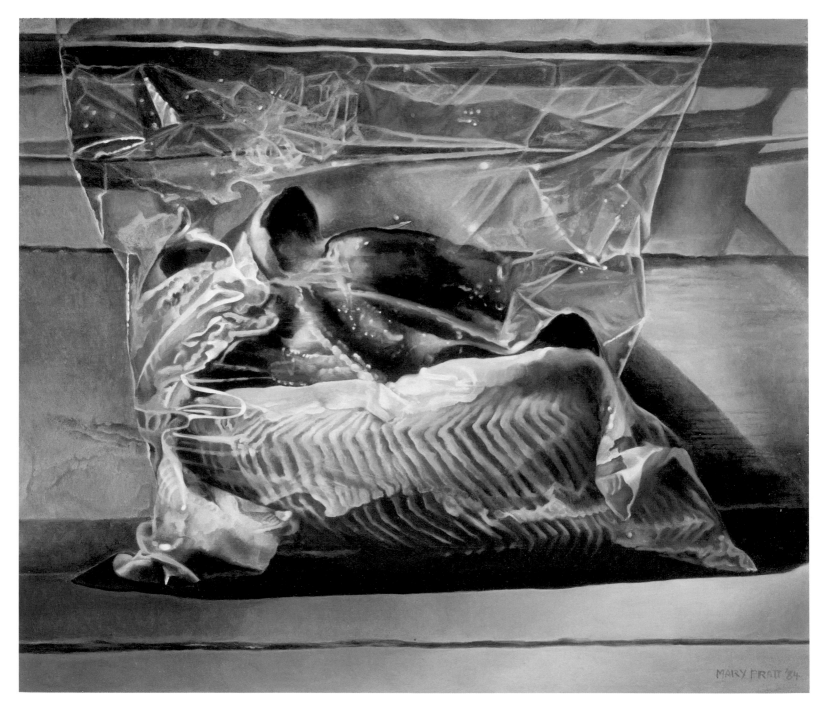

Trout in a Ziploc Bag, 1984
oil on Masonite
38.5 x 46.0 cm

coastal climate extremes prevailed. This cluster of works reveals that her art was concerned with the experiences of location (Fredericton) and relocation (Salmonier) and that it was a self-construction of her life, expressing contrasts of *here* and *there*.

Pratt's paintings emerged in the context of the postwar North American feminist movement. She remarked: "I think of myself quite consciously as a woman painting, and I have quite strong feelings about the women's movement without really being part of it."[45] She would make the family home and kitchen in Salmonier no silent space of oppression but an active location from which to establish a voice of sexual difference and assert the significance of place. Depictions of these gendered spaces exposed the social conditions of her art practice as artist, mother and wife-companion to a fellow artist.

There would never have been reason for Mary Pratt to proclaim the identity "Salmonier-based," as the term would have suggested that she grounded her identity and art practice in that location. Clearly, she had not chosen Salmonier. Rather, it was chosen for her in accordance with prevailing gender norms in marriage, in which tradition gave the husband the authority to determine the location of domestic residence. Pratt endeavoured to live up to the social roles assigned to her by her education, family and marriage. The experience of living in Salmonier provided her with subject matter and space to find her creative voice, but she was isolated from the rest of the world. As she has said, she felt like "a foreigner." For Pratt, there was no obvious advantage to self-identifying with Salmonier as a base point of her art practice. Nonetheless, she turned the experience into a viable and important creative opportunity in a world where prevailing marriage norms did not easily accommodate women being professional artists. ∎

Children's Wharf in September (detail), 1975
oil on canvas
52.1 x 63.5 cm

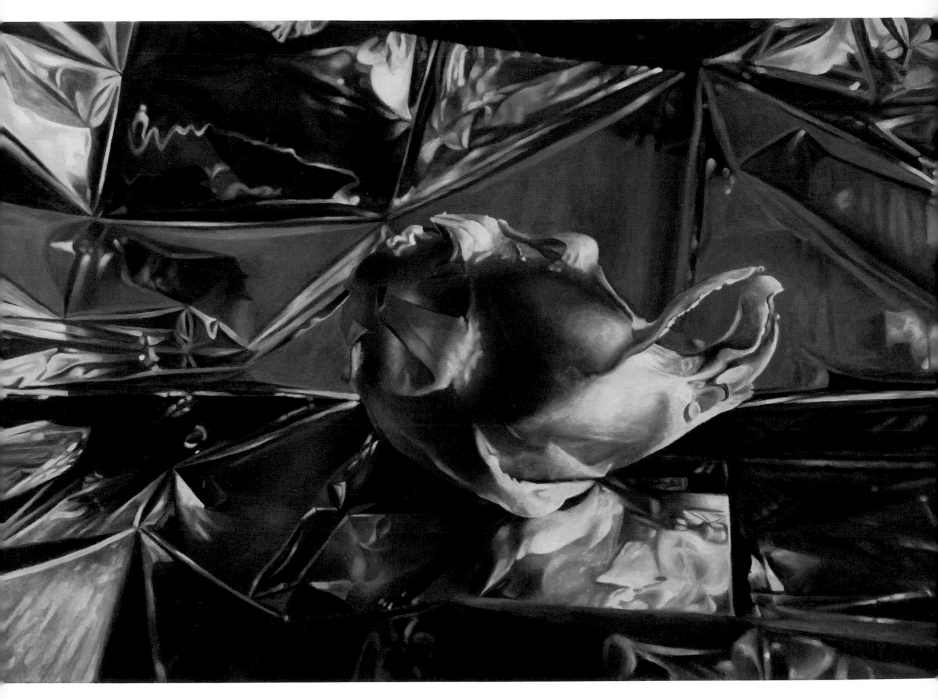

Foiled in Gold, 2007
oil on canvas
50.8 x 76.2 cm

Bedevilling the Real

RAY CRONIN

My point here is that pictorial illusion only has power *as* illusion.
—Dave Hickey, *Air Guitar: Essays on Art & Democracy*

THE GREEK PAINTER Zeuxis is credited by Pliny the Elder with depicting a bunch of grapes so accurately that a flock of birds flew from the sky and tried to eat them. That level of illusion is what many people think of as the epitome of "realism." With apologies to Pliny and Zeuxis, this story really doesn't tell us much about the nature of a painted image. If such mimicry is truly what the artist (and, more importantly, the audience) is after, then why paint after the invention of photography? Mere mimesis, as an end in itself, is rightly distrusted by critics and philosophers and leads to the all too prevalent notion that a painting is merely a "window" through which a viewer looks to see some version of reality. But isn't this a case of being too imaginative? Does the viewer really expect a painting to be "real," and are we actually as literal-minded as Pliny's birds? As the art critic Dave Hickey says, "If anyone who has thought about it for a moment can seriously suggest that anyone in the history of modern culture has ever suspected the picture plane of any picture, however expertly rendered, to be anyplace other than where it is, they have a better imagination than I do."[1]

As much as representation has been distrusted by Modernist theorists, an image is not intrinsically dishonest or simplistic or conservative or uninteresting. Representational images are, I suppose, about the act of representation more than they are about the act of painting, but then isn't *any* painting about representation in the moment that the viewer interacts with it? It doesn't matter if

the painting at which I am looking is representational or not — by looking, by reacting, by thinking about the work, I am treating it as a representation of something, I am reading it as an image. The only way to truly respond to it as a painting in and of itself would be to paint a copy of it and, in so doing, attempt to recreate every one of the thousands of individual decisions that make up any painted image. That's hardly practical, and I suspect one would learn less about the painting with that approach than one would from an honest, open and engaged look at the painting itself.

A painting, let us be clear, is always and only a collection of pigment on a substrate, put there with intention by a person for some purpose. The interesting part of the conversation is about that "purpose" and how it is communicated to me, a viewer. Does the painting *speak* to me, does it *engage* me, does it spark — and hold — my interest?

Pictorial illusion, Dave Hickey has argued, is an important tool humans use to communicate over time. His contention, and I tend to agree, is that illusion can evoke a sense of timelessness, can provide a brief — and yes, illusory — respite from the incessant onward march of time. "Time is a jet plane, it moves so fast,"[2] and that unceasing forward motion can distract us from the moment; it leaves so much in its wake, no matter how hard we may try to hold on to individual moments, things, emotions, even — and I suppose especially — people.

Pictorial illusion, in particular painting, can evoke (was almost certainly invented to evoke) the absent and the desired. A painting, uniquely, can capture those pieces of jetsam lost in time's wake and does so by evoking presence, whereas a photograph, for instance, works by evoking absence. A photograph invariably captures the available light at a moment in time — capturing something that is now gone. A painting, a drawing, an etching, on the other hand, presents us with something that is present, re-present, present again, whatever — it is, and is perceived as, something that is *here*.

In utilizing techniques for pictorial illusion, the artist is not fooling anybody — assuming we are smarter than Pliny's birds. Nevertheless the image becomes the means by which we, ever so briefly, allow ourselves to be fooled. Let me be clear — of course

the map is not the territory, and the picture is not the thing. Realist painting, whatever adjective describes it (be it "social," "super," "photo," "hyper," "magic" or, apropos of the subject of this book, "Atlantic" or "domestic"), is inevitably tied up with questions about the image and its relationship to its ostensible subject.

Mary Pratt is an expert in that evocative illusion, representing — not "capturing" — moments that, despite their basis in her lived experience and in the photographs that are their source material, speak to viewers of their own lives, of their own lost moments. It's as if the paintings are remembering for us.

Reality is both a concrete and a mutable subject, something we think we can grasp but that all too often is in the eye of the beholder. The instant one starts to explain or define reality, an abyss of unreason opens up at one's feet. Why, for instance, should my version of reality be more real than yours? If "seeing is believing," then how can we know that what I am seeing corresponds to your perceptions? The eye — anyone's eye — can be fooled and, in fact, is so every waking second, as our brain turns what we see "right-side up" in the process of translating the visual information that light delivers to the rods and cones of our retinas. However much we understand human perception, how can we claim to know what is really real? And isn't there always more than meets the eye?

In the twentieth century, Realist painting was relegated to the conservative camp, seen as a reactionary response to more avant-garde and innovative approaches to image-making. For instance, in his book *Painting and Reality,* the French philosopher Étienne Gilson dismissed all forms of painting except for Abstraction as being hopelessly retrograde and, interestingly, not sufficiently real. Gilson claimed that there was a difference between the "real" and the "visible," which, of course, there is. But where Gilson, and he is by no means alone, goes wrong is in his contention that painting must be only one thing or another — specifically, "imitative" or "creative."[3] This strict dualism is typical of the period in which Gilson was writing: the mid-1950s, in the heyday of Abstract Expressionism, High Modernism and its seeming endgame for Art itself.

Sixty years on, this triumphalism is misplaced. Pictures are more than mere imitation. That, at least,

Brass, Glass, Peaches and Cream, 2008
oil on canvas
61.0 x 91.4 cm

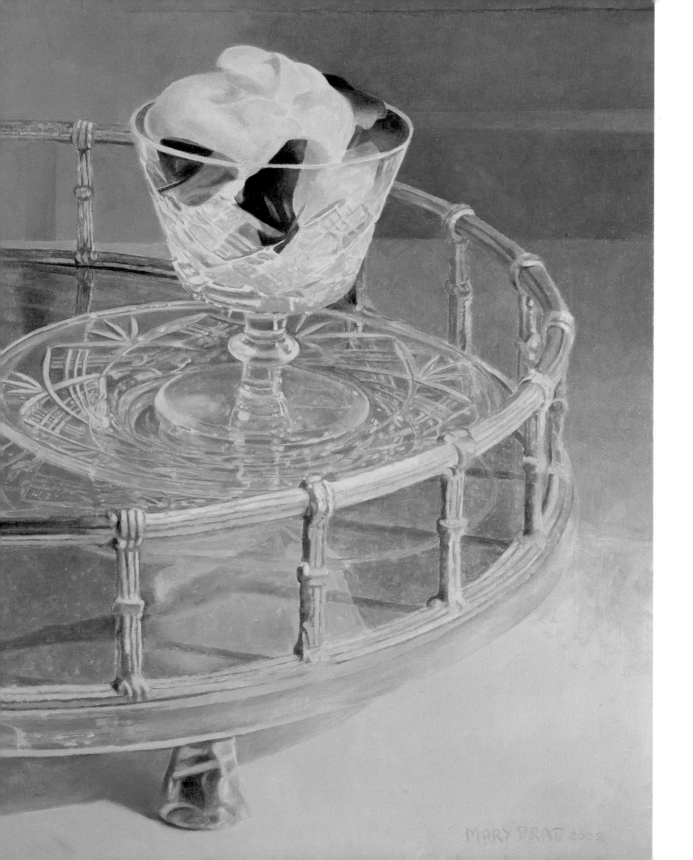

we have learned. Gilson, of course, was citing other sources — and good ones, such as Leonardo da Vinci and Joshua Reynolds — and he got caught in the ancient debate between representation and poetry, in the notion that, somehow, a painting should be more than pigment on a surface and become a new idea or expression. But all of that rhetoric leads to an erroneous conclusion: that painting (or poetry, for that matter) is somehow separable from its constituent parts. If we read a painting as expressing emotion (Pollock) or evoking a presence (Raphael), we are still reading it. A Pollock is no less or more an image than a Raphael — or a Norman Rockwell. By seeing it, I (and any other viewer) invariably turn it into an image and into an object for cognition. Despite the claims of art historians and critics over the decades, Realism and Abstraction are not that different — and one does not have a stronger claim on being "real" than the other. More "interesting"? Well, now, that's a whole other debate. "Interesting," like seeing, is in the eye of the beholder, and unless we are intent on maintaining the evangelical fervour of the Modernists, we must accept that viewers can, and most certainly will, find interest in just about anything.

Realism in art, in particular, is fraught with existential contradictions. As the art historian Linda Nochlin has written: "A basic cause bedevilling the notion of Realism is its ambiguous relationship to the highly problematical concept of reality."[4] That ambiguity, and that problematic concept, is central to the art of Mary Pratt. In fact, as I suggest above, the problem with Realism is actually a problem with language — for a supposed "realist" painting is no more or less real than an abstract. That is, the problematical nature of the concept of reality does not begin with Mary Pratt, but with us.

Like other artists, realists must create a language appropriate to their enterprise. They may or may not reject previous non-realist or anti-realist styles; often their work modifies or adapts them. Yet, on the whole, Realism implies a system of values involving close investigation of particulars; a taste for ordinary experience in a specific time, place and social context; and an art language that vividly transmits a sense of

concreteness. Realism is more than — and different from — wilful virtuosity or the passive reflexivity of the mirror image, however much these may appear as ingredients in realist works.[5]

Nochlin is perhaps the best advocate and most cogent critic of the various forms of Realism, and she has consistently tied twentieth-century Realism to its nineteenth-century antecedents as an act of politics — often, in our times, the specific politics of feminism. Of course, art is more than polemics, as Nochlin — and Mary Pratt — well know. But "a taste for ordinary experience" — that is something that has remained absolutely central to the work of Mary Pratt and to her particular polemic, which has, in part, to do with the value and dignity of the domestic. "In those days, I was a young lady dealing with what was around me. Now I'm an old lady — still surrounded by the same things."[6]

Much of the issue around Realism, and why it seems to keep returning as a problematic concept, is in its own language of representation, of purporting, in paint, to present things "as they really are." That language has its roots in the first Realist movement that swept the art world, one led in the nineteenth century by Gustave Courbet. His realism, however, was not about technique — one could argue that many of the more romantic and expressive painters he was setting himself in opposition to were, in fact, his masters technically, within the terms and scope of the effects and possibilities of paint handling. Courbet did hope to show things as he felt they "really were"; this aspiration was not based in countering progressive trends in art by returning to more popular or so-called "easy" work. On the contrary: for the bourgeois art world of France at mid-century, his work was decidedly hard to look at, as it showed the world outside the academy as it was, warts and all, and eschewed any larger project of allegory or historical allusion. Courbet's "way things are" referred to the social conditions of the poor in France of the day, and he was using his painting for a very contemporary, and radical, purpose. His realism in painting was driven by his social message.

Mary Pratt will not admit to social commentary in

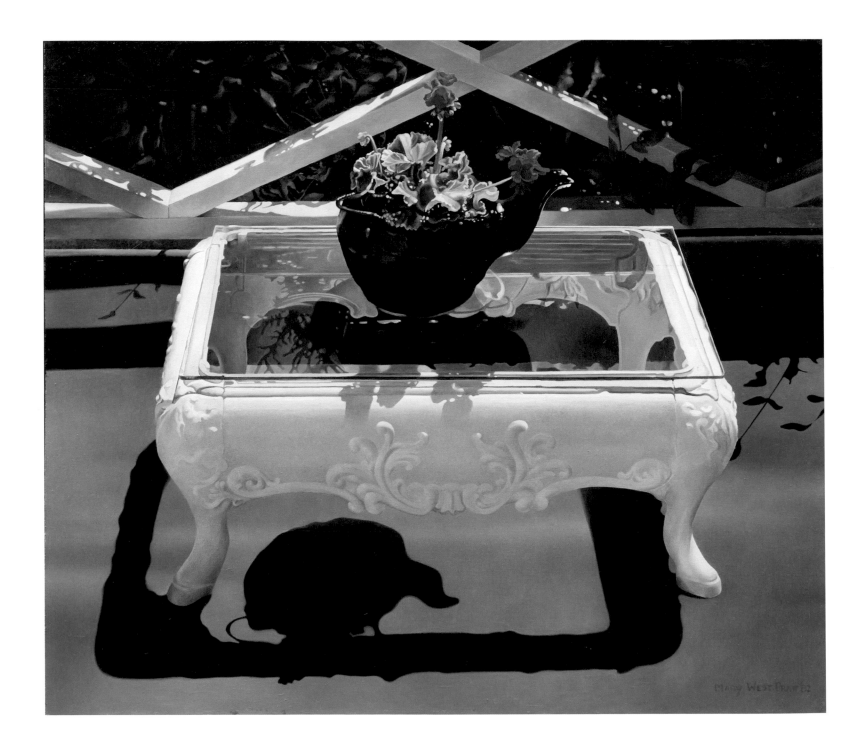

her work, and I am not going to disagree with her. But one cannot look at her whole body of work without seeing that her realism, far from being "magic" or "photo" realism, is rather a social realism — a careful, focused and, indeed, thoughtful look at the state of being immersed in the domestic: the quotidian hurly-burly of meals, laundry, cleaning, child care and all of the other myriad elements that come with the social constructs of "the family" and "the home."

Take *Artifacts on Astroturf,* a painting from 1982. One way of talking about it is to say that one sees a table, a geranium, an iron kettle and a section of deck with its white railing and the eponymous Astroturf. An artifact is a human construction or relic, and Pratt's painting is, in itself, an artifact. This prompts a lively language game that highlights just how fluid our concepts of reality, of naming, of being itself are and how based in habit and convention our approaches to art and language really are. As Magritte so famously demonstrated in his painting *Ceci n'est pas une pipe,* once one starts trying to nail down the relationship between an image and reality, one finds oneself on a slippery slope, sliding toward meaninglessness.

But what is Pratt's painting about? Does it convey some complex symbolic message? What does the geranium mean, for instance, and how do we read the particular quality of the light on the green Astroturf? Well, if one needs to find meanings and symbols in images, then of course one will. But this is not a symbolist painting. It is a moment represented, evoked, an impression, if you will, brought forward in defiance of the jet stream of time.

Another painting, and one no less susceptible to attempts at symbolist reading, is *Sunday Dinner* (1996). It's a simple image: a stretch of wooden counter, a sliver of silver platter and, central to it all, an expanse of raw flesh, glistening red and dappled with white fat. A roast of beef before it goes into the oven — the briefest moment, but one for which an animal died, and in support of which a whole system of distribution and value and employment is arrayed. If asked, Mary Pratt will tell you, as she has told me, that she chooses her images because they are beautiful to her — something catches her eye and she photographs it, and later, perhaps months or even years later, she will find that photograph and

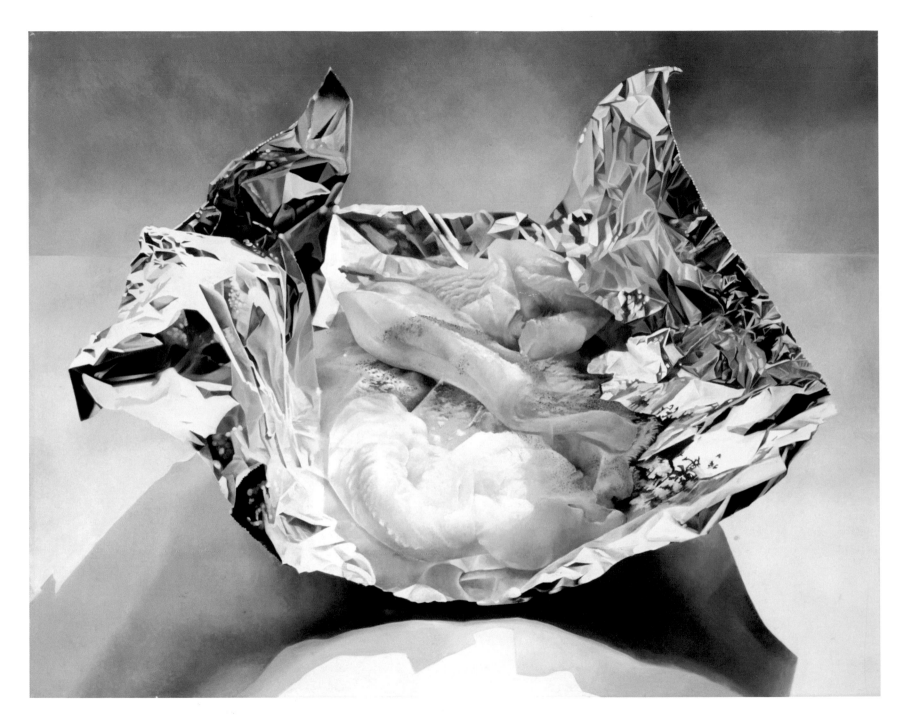

Cod Fillets on Tin Foil, 1974
oil on Masonite
53.3 x 68.6 cm

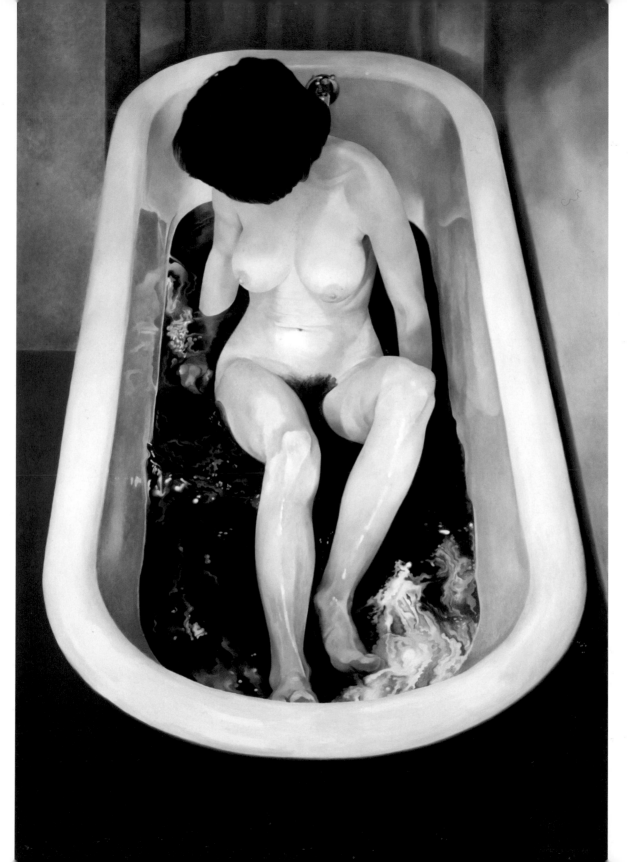

Blue Bath Water, 1983
oil on Masonite
170.2 x 115.6 cm

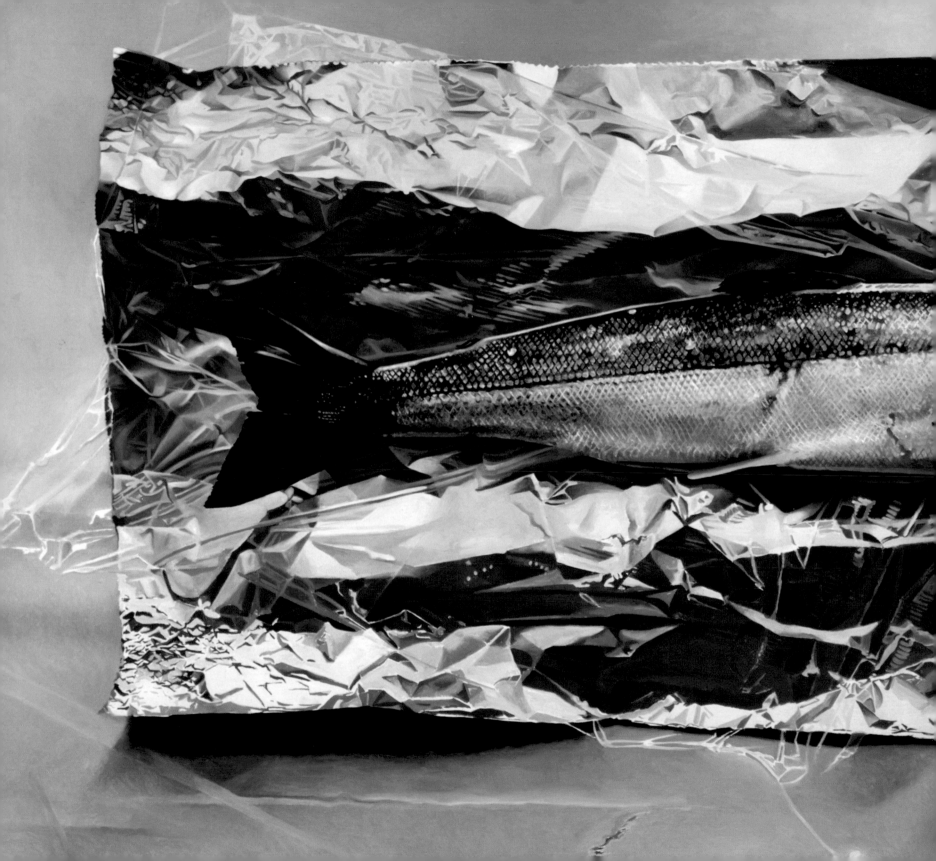

Silver Fish on Crimson Foil (detail), 1987
oil on Masonite
46.7 x 69.5 cm

find something else beautiful about it and will make a painting that evokes the photograph, the memory and that visceral sense of beauty that so defines her sensibility.

Time's passing is ever present in the paintings of Mary Pratt, and not for her the notion that she is creating something "new," something outside of time, something transcending common human experience. I don't think that reflects a lack of ambition, but rather a hard, honest self-awareness. A lack of pretension does not make her work any less interesting.

Presence (the fact of things) and absence (the lack of things) are key ideas in the history of Western philosophy. From Leibniz's plaintive "Why are there things rather than not?" to Kant's exposition on the impossibility of knowing "the thing in itself" to Heidegger's probing of the very notion of not-being, the questions surrounding being and nothingness have been central to a certain strain of metaphysical thinking. That "Why?" — so central to philosophy — is also the main question of religion: it was Job's question, it was Abraham's, it was Mary's and, most famously, it was Jesus's on the cross. Uniquely among

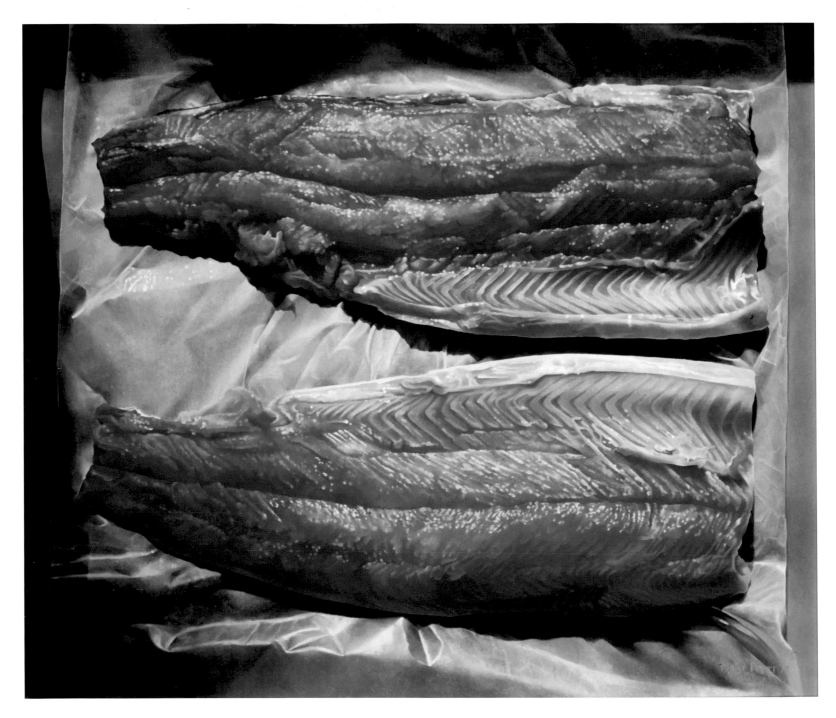

Split Grilse, 1979
oil on Masonite
56.1 x 64.0 cm

our fellow animals, humans ask "Why?" What's more, we set to work and try to provide answers. Art, one could say, is an attempt at both asking and answering, a play between the "why" and the "wherefore."

The quotidian, the everyday, the familiar — egg-shells in the carton, fish on plastic wrap, even a young woman in a dressing gown — these are the moments that Mary Pratt returns to in her paintings, moments in which she has found interest and that she has decided to arrest, to slow down. As Dave Hickey writes, "For three centuries, illusionistic images aimed to slow life down — to make visible the fluid, violent, and often invisible constituents of temporal cultural experience. Then, in the nineteenth century, with the apotheosis of modernity, artists stopped slowing life down into images and began slowing down the images themselves."[7]

In so doing, the Modernists changed the language of painting from being about us to being about painting itself. This undoubtedly made for a lot of great and interesting paintings and did so over a long period of time. But let's be honest: there is only so much that painting can say about itself — and we've long passed the point where its anecdotes about the picture plane have retained any interest.

So what remains for a painting to talk about? Well, anything, everything and nothing, of course. But in the case of Mary Pratt, what remains is what populates our lives. What remains are moments, liberated from memory and shared with the world. Pratt's paintings are presences rather than absences, fullness rather than emptiness. Desire, indeed, is presented in these works, but it is a desire satisfied, not withheld.

Illusion has a place in our lives, a function. We know we're being fooled, we let go of our skepticism for a moment, and in so doing, we're participating in a shared waking dream. Looking at a painting is like reading fiction or watching a magic show: there needs to be a willing suspension of disbelief on our part for the illusion to work. Once again, I'm going to quote Dave Hickey, who writes about illusion as brilliantly as Mary Pratt paints the everyday: "The grandeur of the promise around which these illusions are constructed demystifies the illusions themselves. You never think, How was it done? You simply take pleasure in seeing the impossible appear possible and the invisible made visible. Because if these illusions were not just illusions, we should not be what we are: mortal creatures who miss our dead friends, and thus can appreciate levitating tigers and portraits by Raphael for what they are — songs of mortality sung by the prisoners of time."[8]

Mary Pratt sings those songs of mortality, and in so doing she reaffirms the quiet and refined dignity of human activity that seeks to arrest, if only for a moment, the flow of time and simply be. Answering neither "Why" nor "How," these works nonetheless bedevil our notions of the real, and in their quiet evocations of the beauty of the everyday, they can provide both solace and hope in the inexorable fact of our looming absence from this world. Pratt may not be charming the birds out of the sky, but she makes no apologies on that front. Her illusions, for which we willingly fall, were never meant to be so crass. She does not intend us to try to cook the cod fillets she has depicted, nor to try to put *Sunday Dinner* into the oven. Instead, these images bring to the fore all of our Sunday dinners and make present for us all the people and things that we have passed by on our march through time. Time may indeed feel like a jet plane, moving so fast, and I (and I think Mary Pratt) would agree with Dylan, "Oh, but what a shame if all we've shared can't last."[9]

Indeed. And that, I suppose, is a good reason to paint after the invention of photography. ∎

Entrance, 1979
oil on Masonite
85.4 x 121.9 cm

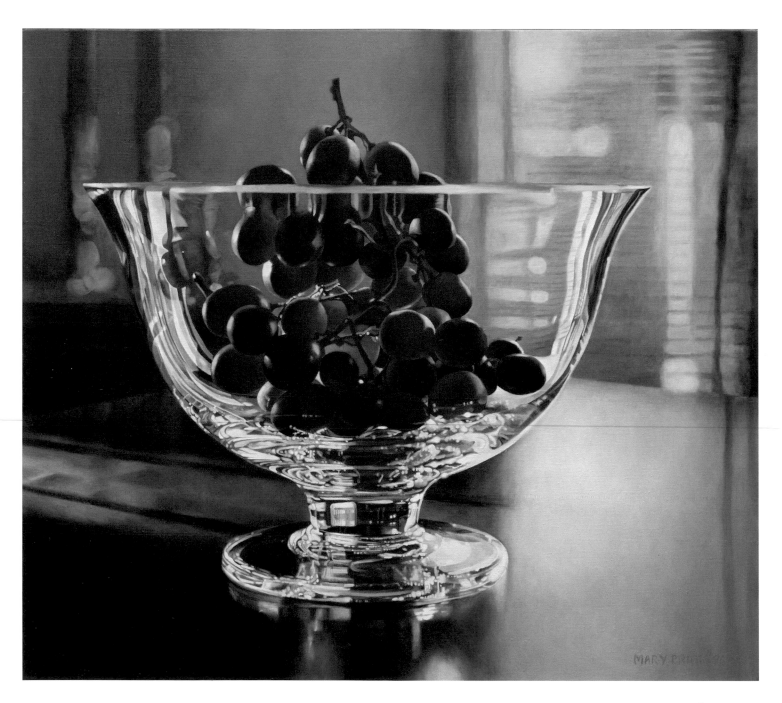

Red Grapes, 1996
oil on canvas
71.1 x 81.3 cm

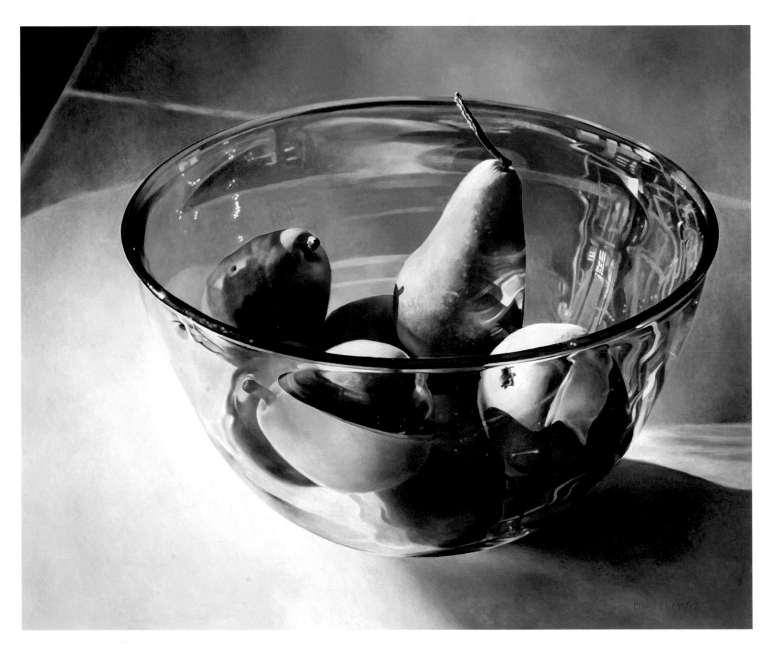

Floating in a Pink Bowl, 1997
oil on canvas
71.1 x 86.4 cm

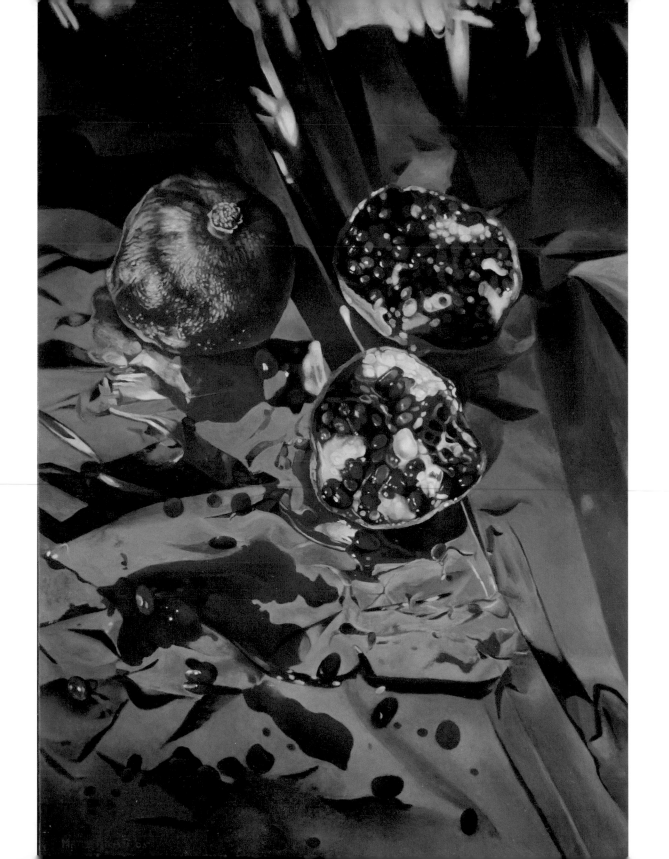

About the Artist
Mary Pratt CC, BFA, RCA, HON. FRAIC

CAROLINE STONE

MARY FRANCES PRATT (née West) was born in Fredericton, New Brunswick, in 1935. She graduated with a Bachelor of Fine Arts from Mount Allison University, Sackville, New Brunswick, in 1961. She had married fellow student Christopher Pratt in 1957, and in 1963 the Pratts moved to St. Catherine's, on the Salmonier River, St. Mary's Bay, in Christopher's home province of Newfoundland — their home became known informally as Salmonier. There they raised four children while pursuing careers as artists. In 1992 Mary Pratt moved to St. John's where she continues to live and work.

In 1967 Mary Pratt's first solo exhibition was held at the Memorial University of Newfoundland Art Gallery in St. John's. Her paintings have been exhibited in most major galleries in Canada and are held by prominent public, corporate and private collections, including those of the National Gallery of Canada (Ottawa), The Rooms Provincial Art Gallery (St. John's), the Art Gallery of Ontario (Toronto), the Beaverbrook Art Gallery (Fredericton), Memorial University of Newfoundland (St. John's) and Canada House (London, England).

Mary Pratt has been the subject of several books and documentaries and has published her own collection of writing on art and life, *A Personal Calligraphy* (2000). She holds honorary degrees from nine Canadian universities, including Memorial University of Newfoundland, the University of Toronto and Dalhousie University. She has served on a variety of government and public committees and boards, in both cultural and broader arenas. Her many honours include the Companion of the Order of Canada (1996), the Canada Council for the Arts Molson Prize and inclusion on the Maclean's Honour Roll (both 1997). In 2012 she

Threads of Scarlet, Pieces of Pomegranate, 2005
oil on canvas
91.4 x 61.0 cm

was given an honorary life membership in the Society of Canadian Artists, made an Honorary Fellow of the College of Fellows of the Royal Architectural Institute of Canada and received the RCA Medal from the Royal Canadian Academy of Arts.

Mary Pratt is represented commercially by Douglas Udell Gallery (Edmonton), Emma Butler Gallery (St. John's), Equinox Gallery (Vancouver) and Mira Godard Gallery (Toronto).

Chronology

Much of the information and all of the quotations in this chronology come from conversations with and correspondence from Mary Pratt during the spring and summer of 2012.

1935

Mary Frances West is born at home on March 15, in Fredericton, New Brunswick.

Her father, prominent lawyer William John West (1892–1985), will later become the province's attorney general and a justice of the Supreme Court of New Brunswick (Queen's Bench Division). Her mother is Katherine Eleanor (McMurray) West (1910–1997).

1938

Her sister, Barbara Catherine (later Cross), is born.

1938–41

Attends Mother Goose Kindergarten, Fredericton.

My kindergarten teacher was Miss Bunker. Trained in Boston, she brought music, art and literature to her students. This early introduction to colours, rhythm and stories had a lasting effect on me, because it was an introduction to formalized thinking — I was three years old.

1941–49

Moves on to Charlotte Street Elementary School, Fredericton. Miss Helen Young, her Grade 1 teacher, introduces her to the world of art — beginning with Raphael's *The Madonna of the Chair*.

I think it was in that year that I began to think of "the painting" as an object worth consideration.

1946

Mary West's painting *Maple Sugar Makers* is included in an international children's exhibition in Paris, France.

School was never very easy for me after Grade 1. Arithmetic was difficult, and I was a lazy student. I was myopic and had to be fitted with glasses when I was about twelve. Feeling embarrassed and awkward, I spent a lot of time painting in my bedroom. I used to work in my cupboard — shut the door, tape papers to the wall and use a clamshell as a palette. This is where I painted Maple Sugar Makers.

When the painting was shown in Paris, my parents decided to encourage me to consider a life of painting. They began to take lessons themselves and read books about artists. They talked about the "look of things."

1949–53

Completes her secondary education at Fredericton High School and is involved in student government.

I continued to study painting — now with Mr. John Todd, a commercial artist who had studied in New York at the Pratt Institute. The only real competition I had came from a very talented

girl — Marie Billings — who knew instinctively how to design complex works. She became a nurse. I still can't do what she never had to learn.

1950–52

During her high school years, she takes summer and evening art classes. Her instructors include Fritz Brandtner (considered by many to be the artist who introduced German Expressionism to Canada), Lucy Jarvis (artist, Director of Art at the University of New Brunswick from 1946 to 1960 and local cultural force) and Alfred Pinsky (artist, teacher and co-founder of the Montreal Artists School).

1953–56

Studies in the fine arts program at Mount Allison University (Sackville, New Brunswick) under Alex Colville, Lawren P. Harris and Ted Pulford, among others.

The art school at Mount Allison was demanding. Long hours spent learning how to draw. In the first years, we used no colour till after Christmas. My back ached, my eyes hurt and I despaired. It was never easy. But it still isn't.

In her first year she meets pre-med student Christopher Pratt from Newfoundland.

1954–57

During the summers she works in (and by 1957, directs) the arts and crafts programs for the City of Fredericton's recreation department.

1956

Graduates with a Fine Arts Certificate, which qualifies her to teach art.

1956–57

Moves to St. John's, Newfoundland, to work as an occupational therapist at the General Hospital, where she uses art as a means of therapy and paints portraits during lunch breaks. She returns to Fredericton in the summer.

1957

On September 12 Mary West and Christopher Pratt marry in Wilmot United Church, Fredericton. Shortly after, they sail to Liverpool aboard the *Nova Scotia,* a Furness Withy & Co. steamer. They are met by Christopher's uncle Art (Pratt). From there they travel by train to Glasgow, Scotland, and rent an apartment on Grosvenor Crescent. Christopher begins studies at the Glasgow School of Art. Mary attempts to join him but is not accepted.

I tried to enroll in the fine arts program to take at least some classes, but…I was pregnant, and the head of the school…didn't think it would be appropriate for me to study at the school in my "condition."

1958

The Pratts travel to St. John's for the birth of their first child, John, in July. Mary takes the infant to Fredericton for the summer before the Pratts return to Scotland (again aboard the *Nova Scotia*). The couple rents a house in Netherlee (near Glasgow), where Mary is mother and homemaker while Christopher studies.

1959

When the school year ends, the family travels to St. John's and then back to Mount Allison. Mary resumes her studies, spreading the courses remaining to complete her BFA over two years. Christopher completes his third-year studies.

1960

In May daughter Anne is born in Fredericton. The Pratts take their young family to St. John's for the summer. They live with Christopher's parents and then return to Sackville and Mount Allison in the fall.

1961

Mary and Christopher Pratt both graduate with BFA degrees in the spring.

During that winter [1960–61], both children were sick a lot, my grandmother died and Christopher decided that we really were going back to Newfoundland. And though I did get my degree, I was not hopeful that I'd ever become much good as a painter. I was tired and pretty fed up.

The family moves to Newfoundland. Mary teaches art two nights a week for Memorial University of Newfoundland's Extension Service, where Christopher is now Specialist in Art. They buy their first home — a small CMHC house on University Avenue in St. John's — and start spending time at a cottage on the Salmonier River (more than an hour away), which Christopher's parents rent from friends.

Mary Pratt's work appears in a group exhibition (*Atlantic Awards Exhibit*) at Dalhousie University in Halifax.

1963

Daughter Barbara is born in St. John's in February. A few months later the family moves to the cottage on the Salmonier, which Christopher's father purchased in 1962.

1964

Son Edwyn (Ned) is born in St. John's in August.

During the mid-1960s Mary snatches time between homemaking tasks to paint, generally choosing subjects close at hand. Christopher takes several coastal voyages in the summers; Mary stays home with their young family.

By 1965–66, [the children were old enough that] I was able to spend a lot of time painting. I had no studio but I was able to paint anywhere in the house, as all I needed was a small easel and a little rolling table. I managed to paint quickly — [in] forty-five minutes — doing small sketches of things around the house. I only once "set up" a still life — the one called Classic Still Life.

I did help Christopher in his studio [in the 1960s] — posed for one painting — but until he began to make silkscreen prints, he didn't need my help.

1967

Mary Pratt's first solo exhibition — *Paintings by Mary Pratt* — is presented at the Memorial University of Newfoundland Art Gallery, St. John's.

My parents came to Newfoundland to attend this "first" show. But there was such a dreadful blizzard that night that they stayed with the

children while Christopher and I made our way to St. John's. The show, which included about forty small sketches — some landscapes, some interiors, some still life — was almost all sold by the time we got there. As it was my birthday, I felt the day had been a gift.

1969

Using a colour slide taken by Christopher, she paints *Supper Table,* which she describes as "the first 'professional' painting of my career." Christopher's father purchases the painting.

1970

She ceases her work on the painting *Eviscerated Chickens* in September and starts sewing classes; by December her family has encouraged her to go back to painting.

My foray into painting with the help of the camera was pushed by Christopher. Only he encouraged me. Critics in St. John's considered it "the end" of my innocence, and my parents figured it was just cheating.

All of this undermined my confidence, and I put away my paints and took sewing lessons. But at Christmas Christopher put the slide of Eviscerated Chickens *in an envelope with a*

note saying, "Please finish this painting or I'll be visiting you in the hospital for nervous diseases." And Barby said, "But Mummy — if you aren't a painter, what can you be?" So I painted.

1973

Joins the Newfoundland government's task force on education, headed by Leslie Harris.

1975

Growing exposure as an Atlantic Canadian artist leads to Mary Pratt's inclusion in the National Gallery of Canada exhibition *Some Canadian Women Artists,* curated to celebrate International Women's Year. And then, personal tragedy struck.

The loss of the twins still means more to me than I care to admit. It had to affect my work.

The first painting I did after I lost the twins was Eggs in an Egg Crate *... All the eggshells were empty — a fact I failed to notice.*

1978

Mary Pratt has her first solo show in a private Toronto gallery, the Aggregation Gallery. She begins to paint nudes.

We had a wonderful model at Mount A, and she
was a friend and a real person. And so, of course,
I was used to painting the naked female.

I never drew Donna Meaney [from life]. At
first I worked from a slide taken by Christopher.
He asked me if I'd like to use the slide of Donna
in the wicker chair… After I had painted Girl in
Wicker Chair, *I asked Christopher to take some*
photographs of her in bathwater stained blue by
bath salts. Then I did quite a lot of photography
of her myself.

The government of Newfoundland again comes
calling: she serves briefly on the Fishing Industry
Advisory Board.

1980–81

She takes on even more public service roles. In 1980
the chief justice of the Trial Division appoints her
one of four lay "Benchers," a governance group of the
Law Society of Newfoundland and Labrador. In 1981
she becomes a member of the Federal Cultural Policy
Review Committee, better known as the Applebaum-
Hébert Committee. Closer to home, she joins the board
of directors for the Grace Hospital in St. John's.

[Serving as a Bencher] was one of the most
interesting things I did outside of the studio —
but when I began to work with the Applebaum-

Hébert Committee I gave up all the outside
interests because it was so time-consuming and
I thought I could contribute more to it than to
other interests unrelated to the arts… It meant
a lot of reading and a lot of travel. I think it
accomplished very little. I had to go to hearings
all over the country, and so I did see a lot of
Canada. But in many ways it was an awful
waste of my time.

1981–82

The London Regional Art Gallery (Ontario) mounts a
major retrospective of Mary Pratt's work, which tours
nationally. The Pratts build a house with two studios in
St. John's, move in briefly and then return to Salmonier.

1983–89

Serves as a member of the board of regents of Mount
Allison University.

1985

In February her father dies. In May she has her first
solo show at the Mira Godard Gallery in Toronto,
where she exhibits regularly from this point on.

I had hoped that my first show at the Mira
Godard Gallery would lead to good reviews and
a step up for me. But I had painted a great many
watercolours for a book of recipes by Cynthia

Wine; some of these watercolours had been framed and hung with my more ambitious oil paintings. They denied the show the importance I had hoped to indicate and served to suggest that I was, after all, "only an illustrator." A lesson learned too late. Still — I did figure out how to use watercolour, and eventually this led to the fire paintings.

Chairs the Advisory Committee to Memorial University of Newfoundland on the Fine Arts School at Sir Wilfred Grenfell College, Corner Brook.

1986

First solo show on Canada's west coast, at the Equinox Gallery in Vancouver, where she continues to have regular exhibitions.

1987

Becomes a board member for the Canada Council for the Arts and serves until 1993.

While I was on the board of the Canada Council, I was lucky enough to meet Canadians who were dedicated to the arts — Celia Franca, Herménégilde Chiasson, Martha Henry, Édith Butler, to name only a few. The staff made most of the decisions, and though we could read what was going on in every discipline and discuss grants, we really had very little power. Still, I enjoyed the people I met, and may have learned a bit about Ottawa.

1988

Becomes a member of the Cultural Industries Sectoral Advisory Group on International Trade (SAGIT), in Ottawa.

1989

Her exhibition *Flames,* at the Mira Godard Gallery in Toronto, showcases new departures in her work: drawings, mixed media and larger pieces. Her life and work are profiled in two books: *Mary Pratt* by Sandra Gwyn and Gerta Moray and *Mary and Christopher Pratt* by Jane Lind.

1990

Using her considerable network of connections, she rallies Canadian artists in support of Confederation, in response to divisive talk surrounding the Meech Lake Accord proceedings.

Along with a great many "thinking" Canadians, I was positive about the Meech Lake Accord. I tried to rally enough support among Canadian artists to give us a voice in the proceedings. But

finally, the connections I had hoped to make in Quebec fell through. I never asked why — I just knew that without that, we were not going to be of much use. But I was sorry when the Accord failed. Politics isn't easy. And I'm not a politician.

1992

Moves to St. John's without Christopher.

1993

Receives the Canadian Conference of the Arts Commemorative Medal for the 125th Anniversary of Confederation, "in recognition of contributions made to the life of the artistic community in Canada."

1994

Inducted into the Newfoundland and Labrador Arts Council Hall of Fame and serves on the Memorial University of Newfoundland Art Gallery Advisory Committee.

1995

Three major exhibitions of her work are mounted: at the Royal Ontario Museum and the Mira Godard Gallery, in Toronto, and at the Beaverbrook Art Gallery, in Fredericton. The latter — *The Art of Mary Pratt: The Substance of Light* — tours nationally through 1997. The accompanying publication by Tom Smart is also released.

1997

Invested as a Companion of the Order of Canada and awarded the Canada Council for the Arts Molson Prize. CBC television airs *The Life and Times of Christopher and Mary Pratt.* Her mother dies at the age of eighty-seven.

1999

Becomes the co-chair (through 2000) of a committee that guides the creation of Newfoundland and Labrador's major new cultural institution, The Rooms which counts the provincial art gallery, archives and museum among its divisions.

2000

A Personal Calligraphy, a collection of her writing, is published by Goose Lane Editions. In 2001 it receives the Newfoundland Herald Non-Fiction Award from the Writers' Alliance of Newfoundland and Labrador.

2004

A decade-long period of work culminates in the touring exhibition *Simple Bliss: The Paintings and Prints of Mary Pratt,* which includes woodcut prints created with master printer Masato Arikushi in Vancouver.

Mary and Christopher Pratt divorce after a twelve-year separation.

2006

Receives the Excellence in Visual Arts (EVA) Long Haul Award from Visual Artists Newfoundland and Labrador (VANL-CARFAC). She marries artist James Rosen in St. John's.

2007

Paul Kennedy, host of CBC radio's *Ideas,* and Mary Pratt engage in a public dialogue at The Rooms on January 13. In early February she delivers an artist's lecture there and is a featured speaker when David Suzuki's cross-country tour "If You Were Prime Minister" comes to town. On February 15 her official portrait of the Right Honourable Adrienne Clarkson, then Governor General of Canada, is unveiled at Rideau Hall, in Ottawa. In March Canada Post releases the *Art Canada: Mary Pratt* series of stamps.

2008

Mary Pratt and James Rosen tour Italy and Spain.

Christopher and I had honed our skills together. It had been a wonderful time — our eyes, our minds still young enough to see and understand without outside interference.

My second husband, artist/professor James Rosen, hoped that visiting the great galleries in Italy and Spain would convince me that art comes from art. However, with the exception

of the Goyas in the Chapel of San Antonio de la Florida in Madrid, the great Cathedral of Monreale in Sicily and the Giottos in the [Scrovegni] Arena Chapel in Padua, I was dazzled but unmoved. Art for me still comes from life.

It has been good to discover new ways of thinking — even though I still prefer my initial way of seeing. These days [summer 2012], I work in St. John's, and Jim is in his studio in Trepassey.

2011

Inside Light, an exhibition of new works by the artist, is held at the Equinox Gallery, Vancouver.

Because of the difficulty of travelling when I can't walk without a lot of trouble, I didn't attend this show at the Equinox Gallery. It was rather like giving birth to a baby and not being allowed to see the child. It was a terrible letdown — and even though the work "sold," I somehow didn't care. I lost the touch and pulse of the occasion. Just to paint and to sell isn't enough for me. I want to see — to know — if people respond to the paintings. I need to know if I have made a difference to anybody.

2012

Despite ill health, Mary Pratt continues to paint, and an exhibition of recent work is held at the Mira Godard Gallery, in Toronto — her twelfth solo show there.

She works with curators at The Rooms Provincial Art Gallery and the Art Gallery of Nova Scotia to prepare the exhibition *Mary Pratt,* which is scheduled to tour the country from 2013 to 2015 with federal and provincial financial support. The project spans five decades of artistic production and is accompanied by a major publication, issued in English and French editions. Ned Pratt acts as photography advisor.

Wedding Dress (detail), 1975
oil on Masonite
115.6 x 58.4 cm

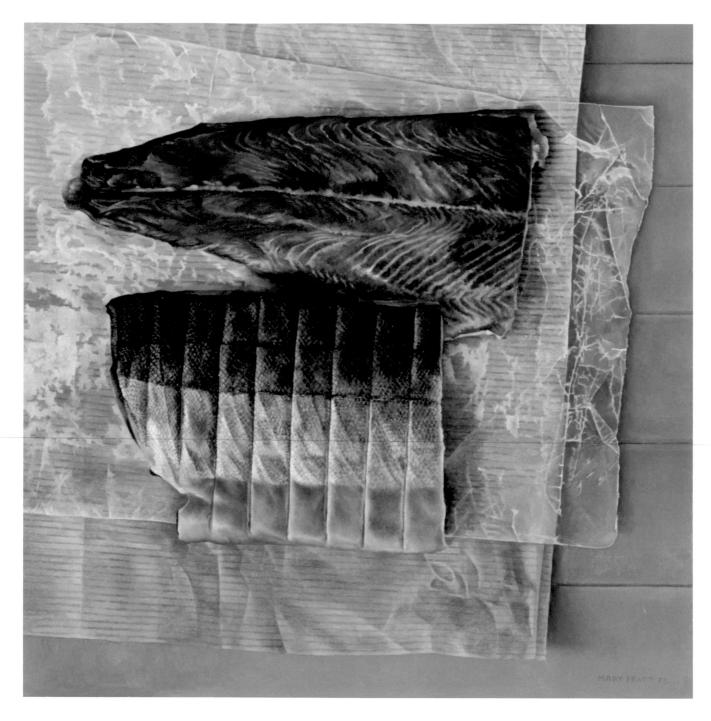

Arctic Char, 1978
oil on Masonite
61.0 x 61.0 cm

Exhibition Chronology and Selected Bibliography

SELECTED EXHIBITIONS
Solo Exhibitions

2012 *Mary Pratt: New Paintings and Works on Paper,* Mira Godard Gallery, Toronto; the most recent of regular solo exhibitions since 1985

2011 *Mary Pratt: Inside Light,* Equinox Gallery, Vancouver; the most recent of regular solo exhibition since 1986

2007 *Mary Pratt: Allusions,* McMichael Canadian Art Collection, Kleinburg, Ontario

2004 *Simple Bliss: The Paintings and Prints of Mary Pratt,* MacKenzie Art Gallery, Regina

1997 *Mary Pratt,* Emma Butler Gallery, St. John's

1995 *The Art of Mary Pratt: The Substance of Light,* Beaverbrook Art Gallery, Fredericton

1986 *Aspects of a Ceremony,* Equinox Gallery, Vancouver

1985 *Mary Pratt,* Mira Godard Gallery, Toronto

1981 *Mary Pratt,* London Regional Art Gallery, London, Ontario

1976 *Mary Pratt: Paintings—A Seven Year Survey,* Aggregation Gallery, Toronto

1975 *Mary Pratt,* Dalhousie Art Gallery, Halifax

 Mary Pratt: Paintings and Drawings, Memorial University of Newfoundland Art Gallery, St. John's

1973 *Mary Pratt Paintings,* Erindale College, University of Toronto, Mississauga, Ontario

 Mary Pratt: A Partial Retrospective, Memorial University of Newfoundland Art Gallery, St. John's

1967 *Paintings by Mary Pratt,* Memorial University of Newfoundland Art Gallery, St. John's

Group Exhibitions

2008 *Learning from Leonardo: The High Realist Legacy in Canadian Art,* MacKenzie Art Gallery, Regina

2006 *The Future Now: Exploring Tomorrow's Collection Today,* Art Gallery of Ontario, Toronto

2002 *Perspectives: Canadian Women Artists,* McMichael Canadian Art Collection, Kleinburg, Ontario

2001 *Pratt, Deichmann, Bobak: The Women,* Beaverbrook Art Gallery, Fredericton

1997 *Discovery,* Lunenburg Art Gallery, Nova Scotia

1994 *Survivors in Search of a Voice: The Art of Courage,* Royal Ontario Museum, Toronto

 Anecdotes and Enigmas: The Marion McCain Atlantic Art Exhibition, Beaverbrook Art Gallery, Fredericton

1990 The Tenth Dalhousie Drawings Exhibition, Dalhousie Art Gallery, Halifax

 Mary Pratt and John Reeves: The Johnny Wayne Portrait, Memorial University of Newfoundland Art Gallery, St. John's

1986 *Twenty-Five Years of Art in Newfoundland: Some Significant Artists,* Memorial University of Newfoundland Art Gallery, St. John's

1980 *12 Canadian Artists,* Robert McLaughlin Gallery, Oshawa, Ontario

1978 *Realism in Canada: Traditional and New,* Norman MacKenzie Art Gallery, Regina

 Strictly People, Canadian Embassy, Washington, D.C.

1977 *Selecting and Collecting,* Harbourfront Art Gallery, Toronto

*Indicates a touring exhibition

1975 *Some Canadian Women Artists,* National Gallery of Canada, Ottawa

1974 *SCAN (Survey of Canadian Art Now),* Vancouver Art Gallery

**9 out of 10: A Survey of Contemporary Canadian Art,* Ontario public galleries

The Acute Image in Canadian Art, Owens Art Gallery, Mount Allison University, Sackville, New Brunswick

1971 *Painters in Newfoundland,* Picture Loan Gallery, Toronto

1969 *Contemporary Painters of Newfoundland,* Memorial University of Newfoundland Art Gallery, St. John's

COLLECTIONS
International Public Collections
Canada House, London, England

National Public Collections
Canada Council Art Bank, Ottawa

National Gallery of Canada, Ottawa

Provincial and Regional Public Collections
Art Gallery of Nova Scotia, Halifax

Art Gallery of Ontario, Toronto

Beaverbrook Art Gallery, Fredericton

Confederation Centre of the Arts, Charlottetown

London Regional Art Gallery (now Museum London), Ontario

New Brunswick Museum, Saint John

Robert McLaughlin Gallery, Oshawa, Ontario

The Rooms Provincial Art Gallery, St. John's

Vancouver Art Gallery

University Collections
Acadia University Art Gallery, Wolfville, Nova Scotia

Blackwood Gallery, University of Toronto Mississauga Campus

Memorial University of Newfoundland Art Gallery, St. John's

Mount Saint Vincent University, Halifax

Owens Art Gallery, Mount Allison University, Sackville

St. Thomas University, Fredericton

University of Guelph Art Gallery, Ontario

University of New Brunswick Art Centre, Fredericton

Corporate Collections
Canada Packers (now Maple Leaf Foods)

Canadian Broadcasting Corporation

CIL

Imperial Oil

Irving Oil

Manufacturers Life (now Manulife Financial)

McCain

Petro-Canada

Royal Bank of Canada

SELECTED BIBLIOGRAPHY
Books & Catalogues

Amesbury, Barbra. *Survivors, in Search of a Voice: The Art of Courage.* Toronto: Woodlawn Arts Foundation, 1995.

Bell, Peter. Introduction to *Mary Pratt: A Partial Retrospective.* St. John's: Memorial University of Newfoundland Art Gallery, 1973.

Canadian Federation of Friends of Museums. *Significant Treasures.* With an introduction by Lynne Teather. Ottawa: CFFM, 1997.

Deadman, Patricia, and Robin Laurence. *Simple Bliss: The Paintings and Prints of Mary Pratt.* Regina: MacKenzie Art Gallery, 2004.

Fulford, Robert. "A Note on Mary Pratt." In *Mary Pratt: Paintings— A Seven Year Survey.* Toronto: Aggregation Gallery, 1976.

Gibson Garvey, Susan. *The Tenth Dalhousie Drawing Exhibition.* Halifax: Dalhousie University, 1990.

Godsell, Patricia. *Enjoying Canadian Painting.* Don Mills, ON: General Publishing, 1976.

Graham, Mayo. *Some Canadian Women Artists.* Ottawa: National Gallery of Canada, 1975.

Gwyn, Sandra, and Gerta Moray. *Mary Pratt.* Toronto: McGraw-Hill Ryerson, 1989.

Lind, Jane. *Mary and Christopher Pratt.* Canadian Artists Series. Vancouver: Douglas & McIntyre, 1989.

Moore, Lisa. *Discovery.* Lunenburg, NS: Lunenburg Art Gallery, 1997.

Murray, Joan. "Mary Pratt: The Skin of Things." In *Mary Pratt.* London, ON: London Regional Art Gallery, 1981

Newlands, Anne. *Canadian Art: From Its Beginnings to 2000.* Richmond Hill, ON: Firefly, 2000.

Reid, Verna. *Women Between: Construction of Self in the Work of Sharon Butala, Aganetha Dyck, Mary Meigs and Mary Pratt.* Calgary: University of Calgary Press, 2008.

Smart, Tom. *The Art of Mary Pratt: The Substance of Light.* Fredericton: Goose Lane Editions / Beaverbrook Art Gallery, 1995.

Articles & Reviews

Andrews, Shari. "Path of the knife; Not a Wrinkle." *TickleAce* 38 (2000): pp. 55–56.

Bruce, Harry. "The Fine Art of Familiarity: Mary Pratt Paints as She Lives—Close to Her Kitchen Sink." *Canadian Magazine,* November 29, 1975, pp. 16–20.

Burnett, David. "'Some Canadian Women Artists': The National Gallery of Canada." *Artscanada* 32, no. 4 (Winter 1975–76): pp. 54–58.

Canadian Art. "Is It Serendipity or Brilliant Planning?" *Canadian Art* 12, no. 4 (December 1995): p. 20.

Collins, Anne. "In and Out of the Kitchen: Mary Pratt." *City Woman* (Summer 1982): pp. 54–56, 58, 60–62.

Daily Gleaner (Fredericton). "Artist Pratt Donates Freud Work to Gallery." June 24, 2004, p. B6.

Dault, Gary Michael. "'I Like Paint Better than Realism.'" *Toronto Star,* May 6, 1978, p. D3.

Gopnik, Blake. "Mary Pratt's Perfect Pictures." *Globe and Mail,* July 20, 1996, p. C14.

Graham, Mayo. "Some Canadian Women Artists." *Artmagazine* 6, no. 24 (December 1975–January 1976): p. 15.

Gwyn, Sandra. "The Newfoundland Renaissance." *Saturday Night* 91, no. 2 (April 1976): pp. 38–45.

Hallett, Susan. "Mary Pratt: The Redeeming Realist." *Canadian Review* 3, no. 2 (May 1976): p. 52.

Laurence, Robin. "Prattfalls: The Bride Strips Bare Her Bachelor." *Border Crossings* 15, no. 2 (Spring 1996): pp. 12–17.

_____. "The Radiant Way." *Canadian Art* 11, no. 2 (Summer 1994): pp. 26–35, cover.

Murray, Joan. "Joan Murray Talking with Mary Pratt." *ArtsAtlantic* 2, no. 1 (Spring 1979): pp. 34–41.

_____. "Mary Pratt." *Artscanada* 35, no. 2 (April/May 1978): p. xvii.

Perlin, Rae. "Mary Pratt: 'Delicate and Sensitive.'" *Evening Telegram* (St. John's), March 25, 1967, p. 12.

Sabat, Christina. "Visual Arts in Review." *Daily Gleaner* (Fredericton), June 26, 1982, p. 5.

Sandals, Leah. "Drawn to the Domestic: Interview with Mary Pratt." *National Post,* August 23, 2007, p. AL8.

Saturday Night. "This Month: A Joy of Surfaces." *Saturday Night* 93, no. 7 (September 1978): p. 8, cover.

Scott, Michael. "The Incredible Lightness of Being Mary Pratt." *Vancouver Sun,* January 6, 1996, pp. B5, B8.

Sunday Express (St. John's). "Pratt Sparks Pro-Canada Rally by National Artists." April 22, 1990, p. 1.

Taylor, Kate. "Visual Artists Seek a Percentage of Resale Riches." *Globe and Mail,* October 29, 2009, p. R9.

Townsend-Gault, Charlotte. "Distant Lines: Art in Newfoundland." *Vanguard* (Vancouver) 13, no. 10 (December 1984–January 1985): pp. 22–25.

Lectures & Scholarly Papers

Buzzell, Judith E. "Media Orientations of Four Women Artists: Questions and Implications for Teaching Art." Master's thesis, Concordia University, 1989.

Mastin, Catharine M. "Beyond 'the Artist's Wife': Women, Artist-Couple Marriage and the Exhibition Experience in Postwar Canada." Doctoral diss., University of Alberta, 2011.

Rasporich, Beverly Matson. "Locating the Artist's Muse: The Paradox of Femininity in Mary Pratt and Alice Munro." In *Woman as Artist: Papers in Honour of Marsha Hanen,* edited by Beverly Matson Rasporich and Christine M. Sutherland, pp. 121–44. Calgary: University of Calgary Press, 1993.

Reid, Verna Maud. "Occupying the Threshold: The Construction of Self in the Work of Sharon Butala, Aganetha Dyck, Mary Meigs and Mary Pratt." PhD diss., University of Calgary, March 2003.

Soto, Cristina I. Sanchez. "The 'Feminist Realism' of Alice Munro and Mary Pratt." Paper presented at Women's Studies Conference at Complutense University of Madrid, 2003.

Online Resources

"Mary Pratt." Art Gallery of Newfoundland and Labrador. "Permanent Collections & Shaped by the Sea." Newfoundland and Labrador Heritage Web Site Project. www.heritage.nf.ca/arts/agnl/mpratt. html.

"Mary Pratt." Library and Archives Canada. "Celebrating Women's Achievements." www.collectionscanada.gc.ca/women/030001-1169-e.html.

"Mary Pratt." National Gallery of Canada. "Collections." www.gallery. ca/en/see/collections/artist.php?iartistid=4435.

"Mary West Pratt." Library and Archives Canada. "Women Artists in Canada." www.collectionscanada.gc.ca/eppp-archive/100/205/301/ ic/cdc/waic/maprat/maprat_e.htm.

Electronic Media

"Christopher and Mary Pratt." *Life and Times*. Toronto: CBC TV, 1997. Videocassette, 60 min.

Growing up Canadian. Directed by Sheila Petzold. Ottawa: Telewerx and GAPC, 2000. Film. Broadcast on History Channel, 2003.

"Infused with Light: A Journey with Mary Pratt." *Adrienne Clarkson Presents*. CBC TV, 1997.

Ideas with Paul Kennedy. CBC Radio, 2005.

The Other Side of the Picture. Produced by Gillian Darling Kovanic. Montreal: National Film Board, in association with CBC, 1999. Videocassette, 53 min.

This Country in the Morning. CBC Radio. 1973, 1974.

Visions. TVOntario, 1983.

Published Work

Guy, Ray. "When Jannies Visited." With illustrations by Mary Pratt. *Canadian Geographic* 113, no. 6 (November–December 1993): pp. 36–43.

Pratt, Mary. "Feature." *Newfoundland Herald* 53, no. 50 (December 12–18, 1998): pp. 47–49.

_____. "Painting the Domestic: Supper Table." *Newfoundland Quarterly* 100, no. 2 (Fall 2007): p. 15.

_____. *A Personal Calligraphy*. Fredericton: Goose Lane Editions, 2000.

_____. "Perspectives." *Education Canada* 38, no. 4 (Winter 1998–99): p. 40.

_____. "Reflections on the Pond." Toronto: Mira Godard Gallery, 1992. Wine, Cynthia. *Across the Table: An Indulgent Look at Food in Canada*. With original watercolours by Mary Pratt. Scarborough, ON: Prentice-Hall, 1985.

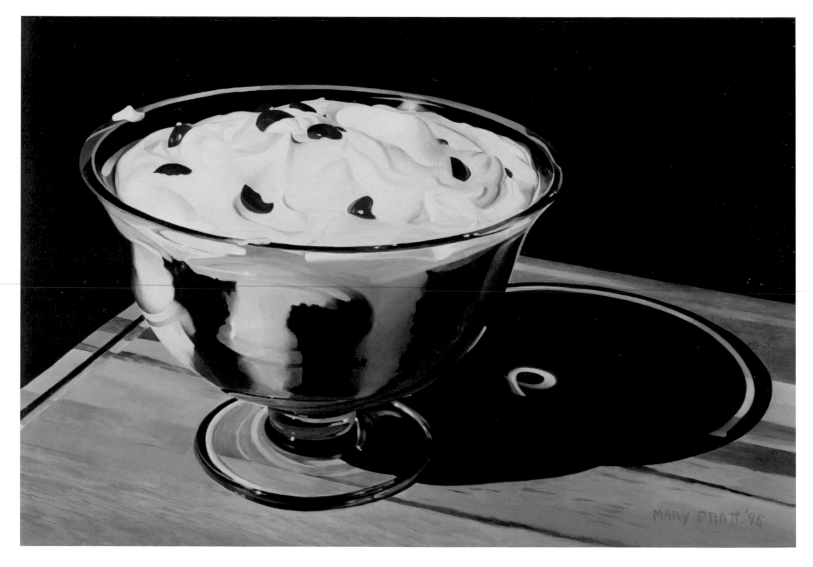

Trifle in a Dark Room, 1995
oil on canvas
55.7 x 77.4 cm

Notes

Look, Here

Note on the opening quotations: Bliss Carman (1861–1929) was a Canadian poet born in Fredericton, New Brunswick. "Earth Voices" was published in *April Airs: A Book of New England Lyrics* (Boston, 1916). The quotation from *A Personal Calligraphy* can be found on page 82.

1. Mary Pratt, *A Personal Calligraphy* (Fredericton: Goose Lane Editions, 2000), p. 99.

2. Mary Pratt, in conversation with the author, November 30, 2011 (St. John's).

3. Pratt, *A Personal Calligraphy,* p. 13.

4. Mary Pratt, in conversation with the author, November 30, 2011 (St. John's).

5. Ibid.

6. Jane Lind, *Mary and Christopher Pratt* (Vancouver: Douglas & McIntyre, 1989), pp. 19–20.

7. Pratt, *A Personal Calligraphy,* pp. 60–61.

8. Although from a similar period, the works are not intended to provide a chronological survey but rather a sampling of various subjects.

9. David P. Silcox, "Icons: Images of Canada," in *The Group of Seven and Tom Thomson* (Richmond Hill, ON: Firefly Books, 2003), p. 49.

10. Giorgio Agamben, "What Is the Contemporary?," in *What Is an Apparatus? and Other Essays,* trans. David Kishik and Stefan Pedatella (Palo Alto, CA: Stanford University Press, 2009), p. 40.

11. Pratt, *A Personal Calligraphy,* p. 107.

12. Lucy Lippard, *The Lure of the Local* (New York: New Press, 1998), p. 7.

Vanitas

1. Siri Hustvedt, *Mysteries of the Rectangle: Essays on Painting* (New York: Princeton Architectural Press, 2005), p. 19.

2. Sandra Gwyn and Gerta Moray, *Mary Pratt* (Toronto: McGraw-Hill Ryerson, 1989), p. 1.

3. Hustvedt, p. 58.

4. Italo Calvino, *Mr. Palomar,* trans. William Weaver (New York: Harcourt Brace Jovanovich, 1985), p. 34. Originally published as *Palomar* (Torino: Giulio Einaudi Editore, 1983).

5. Paddy O'Brien, "Mary Pratt," *Canadian Woman Studies* 3, no. 3 (1982): pp. 36–39.

6. Erika Langmuir, *A Closer Look: Still Life* (London: National Gallery / Yale University Press, 2010), p. 5.

7. Ibid., p. 50.

8. Norman Bryson, *Looking at the Overlooked: Four Essays on Still Life Painting* (London: Reaktion Books, 1990), p. 7.

9. Mary Pratt, in conversation with the author, May 31, 2011.

10. Hustvedt, p. xv.

11. Tom Smart, *The Art of Mary Pratt: The Substance of Light* (Fredericton: Goose Lane Editions / Beaverbrook Art Gallery, 1995), p. 33.

12. Ibid., p. 36.

13. Gwyn and Moray, *Mary Pratt,* p. 12.

14. Ibid., p.13.

15. Steve Edwards, *Photography: A Very Short Introduction* (New York: Oxford University Press, 2006), p. 99.

16. Mary Pratt, in conversation with the author, January 2011.

17. Ibid.

18. Ibid.

19. Smart, *The Art of Mary Pratt,* p. 26.

20. Mary Pratt, in conversation with the author, January 2011.

Base, Place, Location and the Early Paintings

1. Marla Hlady, Paul Wong and Barbara Balfour are examples of artists who use such self-identification.

2. This essay draws on research for my PhD dissertation (completed in 2012); I thank the following for financial support: the University of Alberta for four doctoral and dissertation fellowships, the Social Sciences and Humanities Research Council of Canada, the Kent Haworth Archival Research Fellowship at York University and the Joy Harvie Maclaren Fellowship at Glenbow Museum.

3. Mary Pratt, in conversation with the author, October 17, 2009 (St. John's).

4. Pratt was president of the student council and also, as noted in her school records, showed extraordinary capacity for academic study. Educational Records, 1942–47, file-2003.35/1/7, Mary Pratt fonds, Mount Allison University Archives, Sackville, New Brunswick (hereafter cited as MAUA).

5. Fredericton High School yearbook, *The Graduate, 1953,* Educational Records, 1942–47, file-2003.35/1/7, Mary Pratt fonds, MAUA.

6. William J. West graduated from Harvard University, practised law and politics in New Brunswick and was appointed a judge of the Divorce Court, the Chancery Court and the Appeal Division of the Supreme Court. He authored a family history, *The Wests of Coles Island: The Story of a Family* (1982). The website by genealogist Ruby Cusack, "The Wests of Coles Island" at rubycusack.com, also documents some of this history.

7. Sandra Gwyn and Gerta Moray, *Mary Pratt* (Toronto: McGraw-Hill Ryerson, 1989), p. 6; and interview with the author, October 17, 2009 (St. John's).

8. As quoted by Sandra Gwyn, "Introduction," in Gwyn and Moray, *Mary Pratt,* p. 8.

9. Mary Pratt, *Diary of 1977–1979,* entry for December 19, 1977, file 2008.1/2/3, Mary Pratt fonds, MAUA.

10. Tom Smart, *The Art of Mary Pratt: The Substance of Light* (Fredericton: Goose Lane Editions / Beaverbrook Art Gallery, 1995), p. 39; and M. Pratt, *Diary of 1977–1979.*

11. M. Pratt, *Diary of 1977–1979.*

12. Christopher worked at Memorial University in this position for two years.

13. As quoted by Joan Murray, "The Skin of Things," in Joan Murray and Paddy O'Brien, *Mary Pratt* (London: London Regional Art Gallery, 1981), np.

14. Mary Pratt, as quoted in Cathy Shaw, "Women Honoured for Achievements at Dal Convocation," *Halifax Mail Star,* May 11, 1985, p. 21.

15. Ibid.

16. An overview of realist art in Canada is Paul Duval's *High Realism in Canada* (Toronto: Clark, Irwin, 1974), in which a chapter is devoted to Christopher Pratt. The only female painter included in this book is Christiane Pflug. Christopher Pratt's *Cottage* is both the front cover illustration and the frontispiece illustration in David P. Silcox and Merike Weiler, *Christopher Pratt* (Toronto: Prentice-Hall Canada / Key Porter Books, 1982).

17. Her instructors included Lucy Jarvis, Fritz Brandtner, John Todd and Alfred Pinsky.

18. Christina Sabat, "The Delectable Art of Mary Pratt," *Atlantic Advocate* 73, no. 3 (November 1982): p. 13.

19. W.J. West had facilitated Alex Colville's involvement in redesigning the Wilmot United Church sanctuary in red, blue and brown colour schemes to emphasize the Gothic architecture. See the Wilmot United Church website, wilmotuc.nb.ca, "A Tour of the Church Building" and "A Brief History." W.J. West also supported Mary's study with Colville at Mount Allison. It is no surprise, then, that Colville attended Mary West and Christopher Pratt's wedding (as witnessed by his signature in their wedding autograph book). Mary Pratt's *Wedding Autograph Book,* file 2008.31/2/1-2, Mary Pratt fonds, MAUA.

20. As cited in Robin Laurence, "The Radiant Way: Although Mary Pratt's World Has Grown Darker, Her Paintings Continue to Burn with Startling Incandescence," *Canadian Art* 11, no. 2 (Summer 1994): pp. 26–35.

21. Ibid.

22. Smart, *The Art of Mary Pratt,* p. 45.

23. For a social history of the health risks of the birth control pill in these years, see Elizabeth Siegel Watkins, "Debating the Safety of the Pill," in *On the Pill: A Social History of Oral Contraceptives, 1950–1970* (Baltimore: Johns Hopkins University Press, 1998), pp. 73–102.

24. The four Pratt children are John (b. 1958), Anne (b. 1960), Barbara (b. 1963) and Edwyn (Ned, b. 1964).

25. Mary Pratt's papers include her family correspondence, and these letters form important documentation of the efforts she made to address her isolation.

26. The Pratts remained at Salmonier for nearly three decades. For Christopher it would always be home, but Mary left on their official separation in 1992 and moved to St. John's. The couple divorced in 2004. "Chronology," in *Christopher Pratt: All My Own Work,* ed. Josée Drouin-Brisebois (Vancouver: Douglas & McIntyre; Ottawa: National Gallery of Canada, 2005), p. 121.

27. *Mary Pratt* (St. John's: Memorial University of Newfoundland Art Gallery, 1967), copy in the National Gallery of Canada artist's file; and Peter Bell, "Mary Pratt—Introduction," in *Mary Pratt: A Partial Retrospective* (St. John's: Memorial University Art Gallery, 1973), np.

28. Lucy Lippard observed that "[female artists] work from such imagery because it's there … they can't escape it … In the early 1960s male artists moved into women's domain and pillaged with impunity. The result was Pop Art, the most popular American art movement ever … If the first major Pop

artists had been women the movement might never have gotten out of the kitchen." "Household Images in Art," in *From the Center: Feminist Essays on Women's Art* (New York: E.P. Dutton, 1976), p. 56.

29. Sandra Gwyn, "Introduction," in Gwyn and Moray, *Mary Pratt,* p. 19.

30. Pratt stated that "she will never sell" *Supper Table.* Jane Lind, *Mary and Christopher Pratt* (Vancouver: Douglas & McIntyre, 1989), p. 9.

31. Ibid., p. 12.

32. The slide image from which she worked is illustrated in Smart, *The Art of Mary Pratt,* p. 57.

33. This blue-and-white striped pattern was originally produced by T.G. Green of Britain in the 1920s; it was known as Cornishware and was widely circulated in the 1950s, as documented on the website retroselect.com, consulted January 10, 2010.

34. Mary Pratt, as quoted by Moray, "Critical Essay," in Gwyn and Moray, *Mary Pratt,* p. 38.

35. Mary Pratt, *A Personal Calligraphy* (Fredericton: Goose Lane Editions, 2000), p. 17.

36. There is the later dinner table painting, *Dinner for One* (1994), in which Pratt set the table for her life alone after separation from Christopher, illustrated in Smart, *The Art of Mary Pratt,* p. 133.

37. Pratt has also acknowledged the benefits of life in Newfoundland. In 1986 she stated, "Newfoundland has given me a great deal—one of its most illustrious sons for a husband, a family tradition in both business and the arts for my children to consider, and a generous society in which to satisfy an ambition developed years ago in New Brunswick." As cited in "Convocation Address, Memorial University of Newfoundland and Labrador" (1986), in *A Personal Calligraphy,* p. 86.

38. There is reference to Mary's family visiting them for her 1967 exhibition in Christopher Pratt, *Ordinary Things: A Different Kind of Voyage* (St. John's: Breakwater Books, 2009), p. 32.

39. Mary Pratt, as quoted by Moray, "Critical Essay," in Gwyn and Moray, *Mary Pratt,* p. 56.

40. Ibid., p. 48.

41. C. Pratt, *Ordinary Things*, p. 124.

42. Mary Pratt, as quoted by Moray, "Critical Essay," in Gwyn and Moray, *Mary Pratt,* p. 60, and illustrated on p. 61.

43. Ibid., p. 52.

44. Ibid.

45. As cited in *Mary Pratt: Paintings and Drawings* (St. John's: Memorial University of Newfoundland Art Gallery, 1975), np.

Bedevilling the Real

1. Dave Hickey, "This Mortal Magic," in *Air Guitar: Essays on Art and Democracy* (Los Angeles: Art Issues Press, 1997), p. 185.

2. Bob Dylan, "You're a Big Girl Now," *Blood on the Tracks,* Columbia Records, 1975.

3. Étienne Gilson, *Painting and Reality* (New York: Meridian Books, 1959), p. 233.

4. Linda Nochlin, *Realism* (New York: Penguin Books, 1971), p. 13.

5. Linda Nochlin, "The Realist Criminal and the Abstract Law," in *Theories of Contemporary Art*, ed. Richard Hertz (Englewood Cliffs, NJ: Prentice-Hall, 1985), pp. 25–26.

6. Mary Pratt, in conversation with the author, January 13, 2012.

7. Hickey, *Air Guitar*, pp. 185–86.

8. Ibid., p. 189.

9. Dylan, "You're a Big Girl Now."

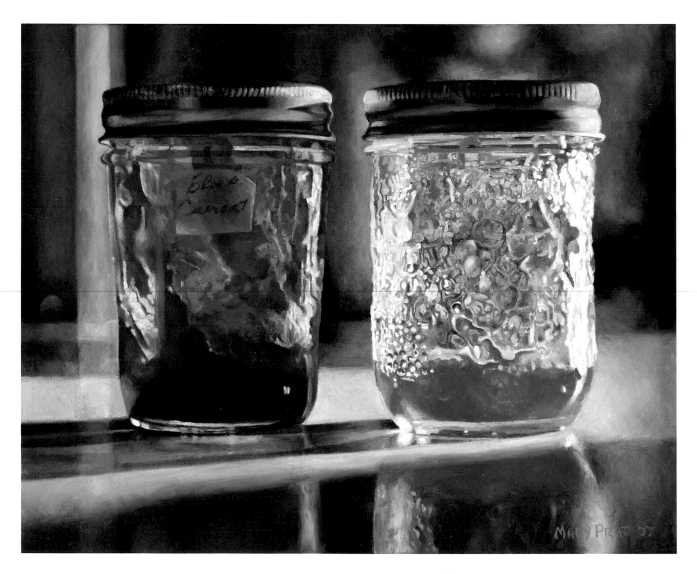

Smears of Jam, Lights of Jelly, 2007
oil on canvas
40.6 x 50.8 cm

Works in the Exhibition

The Bed, 1968
oil on canvas
91.4 x 91.4 cm
Private collection

Cake, Apples and Potatoes, 1969
oil on Masonite
82.5 x 52.1 cm
The Rooms Provincial Art Gallery, Memorial University of
Newfoundland Collection, St. John's, Newfoundland and
Labrador
Photography: Ned Pratt, St. John's

Supper Table, 1969
oil on canvas
61.0 x 91.4 cm
Collection of Mary Pratt

Bags, 1971
oil on Masonite
45.7 x 63.5 cm
The Rooms Provincial Art Gallery, Memorial University of
Newfoundland Collection, St. John's, Newfoundland and
Labrador
Photography: Ned Pratt, St. John's

Eviscerated Chickens, 1971
oil on Masonite
45.7 x 54.0 cm
The Rooms Provincial Art Gallery, Memorial University of
Newfoundland Collection, St. John's, Newfoundland and
Labrador

Pears #1, 1971
oil on Masonite
35.5 x 45.6 cm
The Rooms Provincial Art Gallery Collection, St. John's,
Newfoundland and Labrador, Gift of Philip Pratt
Photography: Ned Pratt, St. John's

Pears #2, 1971
oil on Masonite
35.5 x 45.6 cm
The Rooms Provincial Art Gallery Collection, St. John's,
Newfoundland and Labrador, Gift of Philip Pratt
Photography: Ned Pratt, St. John's

Trout in Pan (Frying Trout), 1971
oil on Masonite
43.2 x 53.3 cm
Private collection
Photography: Sean Weaver, Toronto

Fredericton (Waterloo Row), 1972
oil on Masonite
76.2 x 116.8 cm
Private collection

Dick Marrie's Moose, 1973
oil on Masonite
91.4 x 61.0 cm
Blackwood Gallery Permanent Collection, University of
Toronto, Mississauga, Ontario

Cod Fillets on Tin Foil, 1974
oil on Masonite
53.3 x 68.6 cm
Collection of Angus and Jean Bruneau

Salmon on Saran, 1974
oil on Masonite
45.7 x 76.2 cm
Collection of Angus and Jean Bruneau

Children's Wharf in September, 1975
oil on canvas
52.1 x 63.5 cm
Collection of Lona Warren
Photography: Ned Pratt, St. John's

Cod Fillets in Cardboard Cartons, 1975
oil on Masonite
49.5 x 73.0 cm
Collection of the Art Gallery of Ontario, Toronto

Eggs in an Egg Crate, 1975
oil on Masonite
50.8 x 61.0 cm
The Rooms Provincial Art Gallery, Memorial University of
Newfoundland Collection, St. John's, Newfoundland and
Labrador

Wedding Dress, 1975
oil on Masonite
115.6 x 58.4 cm
Private collection
Photography: Karen Stentaford, Sackville

Pyrex on Gas Flame, 1977
oil on Masonite
30.5 x 33.5 cm
Private collection
Photography: John Dean, Calgary

Roast Beef, 1977
oil on Masonite
41.9 x 57.2 cm
The Museum London Collection, Ontario

Another Province of Canada, 1978
oil on Masonite
91.4 x 69.8 cm
The Rooms Provincial Art Gallery, Memorial University of
Newfoundland Collection, St. John's, Newfoundland and
Labrador
Photography: Ned Pratt, St. John's

Arctic Char, 1978
oil on Masonite
61.0 x 61.0 cm
Private collection

Service Station, 1978
oil on Masonite
101.6 x 76.2 cm
Collection of the Art Gallery of Ontario, Toronto

Entrance, 1979
oil on Masonite
85.4 x 121.9 cm
Collection of The Beaverbrook Art Gallery, Fredericton,
New Brunswick. Purchased with funds from the Canada
Council for the Arts (Special Purchase Assistance Program)
and the Estate of Mrs. Moe Atkinson Benoit.

Split Grilse, 1979
oil on Masonite
56.1 x 64.0 cm
McMichael Canadian Art Collection, Kleinburg, Ontario,
Gift of ICI Canada Inc.

Christmas Turkey, 1980
oil on Masonite
45.7 x 59.7 cm
Collection of the Robert McLaughlin Gallery, Oshawa,
Ontario

Grilse on Glass, 1980
oil on Masonite
50.8 x 66.0 cm
Private collection

Tied Boat, 1980
oil on Masonite
45.7 x 45.7 cm
Private collection
Photography: Ned Pratt, St. John's

Bowl'd Banana, 1981
oil on gesso on Masonite
60.9 x 50.8 cm
Collection of Richard Gwyn and Carol Bishop-Gwyn

Christmas Fire, 1981
oil on Masonite
76.2 x 59.7 cm
Lavalin Collection of Musée d'art contemporain
de Montréal, Quebec
Photography: Centre de documentation Yvan Boulerice

Fire Barrel, 1981
oil on Masonite
66.0 x 45.7 cm
Collection of Beth Pratt

Girl in My Dressing Gown, 1981
oil on Masonite
152.4 x 76.2 cm
Private collection

Artifacts on Astroturf, 1982
oil on Masonite
68.6 x 81.3 cm
Collection of the Art Gallery of Nova Scotia, Halifax

Blue Bath Water, 1983
oil on Masonite
170.2 x 115.6 cm
Collection of Jennifer Wells Schenkman

Child with Two Adults, 1983
oil on Masonite
53.7 x 53.7 cm
Private collection

Cold Cream, 1983
pencil and oil on Masonite
48.3 x 41.3 cm
Collection of The Beaverbrook Art Gallery, Fredericton,
New Brunswick, Gift of Mary Pratt

Fish Head in Steel Sink, 1983
oil on Masonite
52.1 x 77.5 cm
Private collection
Photography: Karen Stentaford, Sackville

Hollowed Eggs for Easter, 1983
oil and gesso on Masonite
76.2 x 91.4 cm
Permanent Collection, Acadia University Art Gallery,
Wolfville, Nova Scotia

In the Bathroom Mirror, 1983
oil on Masonite
106.2 x 65.7 cm
Collection of the Art Gallery of Hamilton, Ontario

Trout in a Ziploc Bag, 1984
oil on Masonite
38.5 x 46.0 cm
Collection of the Vancouver Art Gallery, British Columbia,
Gift of J. Ron Longstaffe
Photography: Jim Gorman, Vancouver Art Gallery

Romancing the Casserole, 1985
oil on Masonite
50.8 x 71.1 cm
Collection of the Owens Gallery, Mount Allison University,
Sackville, New Brunswick, Gift of Mary Pratt

Barby in the Dress She Made Herself, 1986
oil on Masonite
90.8 x 60.3 cm
Private collection

Donna, 1986
oil on Masonite
90.2 x 69.9 cm
The Rooms Provincial Art Gallery, Memorial University of
Newfoundland Collection, St. John's, Newfoundland and
Labrador

Donna with Powder Puff, 1986
oil on Masonite
55.9 x 34.9 cm
Collection of Lois Hoegg and Ches Crosbie
Photography: Ned Pratt, St. John's

Bedroom, 1987
oil on Masonite
114.3 x 96.5 cm
Collection of the Right Honourable Adrienne Clarkson

Girl in Glitz, 1987
oil on Masonite
76.2 x 114. 9 cm
Collection of the Art Gallery of Ontario, Toronto

Silver Fish on Crimson Foil, 1987
oil on Masonite
46.7 x 69.5 cm
Collection of Brendan and Renée Paddick

This Is Donna, 1987
oil on canvas
185.4 x 106.7 cm
Collection of The Beaverbrook Art Gallery, Fredericton,
New Brunswick

Pheasant with Lace and Velvet, 1990
mixed media on paper
161.3 x 119.4 cm
Collection of Mount Allison University, Sackville,
New Brunswick, Gift of Mary Pratt

Green Grapes and Wedding Presents with Half a Cantaloupe, 1993
oil on canvas
61.0 x 91.4 cm
Collection of Royal Bank of Canada

Dinner for One, 1994
oil on canvas
61.0 x 91.4 cm
Private collection
Photography: Rachel Topham, Vancouver

Glassy Apples, 1994
oil on canvas
46.0 x 61.0 cm
Collection of The Beaverbrook Art Gallery, Fredericton, New Brunswick, Bequest of Harrison McCain, C.C.

The Dining Room with a Red Rug, 1995
oil on linen
91.4 x 137.2 cm
Collection of The Beaverbrook Art Gallery, Fredericton, New Brunswick, Gift of Mary Pratt

Trifle in a Dark Room, 1995
oil on canvas
55.7 x 77.4 cm
Collection of the Art Gallery of Greater Victoria, British Columbia

Lupins in Christopher's Burned Studio, 1996
oil on canvas
50.8 x 40.6 cm
Private collection

Red Grapes, 1996
oil on canvas
71.1 x 81.3 cm
Hamill Family Collection
Photography: Rachel Topham, Vancouver

Sunday Dinner, 1996
oil on canvas
91.4 x 121.9 cm
Collection of the Art Gallery of Nova Scotia, Halifax

Chocolate Birthday Cake, 1997
oil on canvas
60.9 x 76.2 cm
Hamill Family Collection
Photography: Rachel Topham, Vancouver

Dishcloth on Line #1, 1997
mixed media on paper
57.2 x 76.2 cm
The Rooms Provincial Art Gallery, Government of Newfoundland and Labrador Collection, St. John's, Newfoundland and Labrador
Photography: Ned Pratt, St. John's

Dishcloth on Line #2, 1997
mixed media on paper
57.2 x 76.2 cm
The Rooms Provincial Art Gallery, Government of Newfoundland and Labrador Collection, St. John's, Newfoundland and Labrador
Photography: Ned Pratt, St. John's

Dishcloth on Line #3, 1997
mixed media on paper
57.2 x 76.2 cm
The Rooms Provincial Art Gallery, Government of Newfoundland and Labrador Collection, St. John's, Newfoundland and Labrador
Photography: Ned Pratt, St. John's

Dishcloth on Line #4, 1997
mixed media on paper
57.2 x 76.2 cm
The Rooms Provincial Art Gallery, Government of Newfoundland and Labrador Collection, St. John's, Newfoundland and Labrador
Photography: Ned Pratt, St. John's

Floating in a Pink Bowl, 1997
oil on canvas
71.1 x 86.4 cm
Collection of Lois Hoegg and Ches Crosbie
Photography: Ned Pratt, St. John's

Bowl'd Doultons, 1998
oil on canvas
66.0 x 81.3 cm
Collection of Royal Bank of Canada

Cherries, 1998
oil on Masonite
33.0 x 55.9 cm
Collection of Equinox Gallery, Vancouver, British Columbia
Photography: Ned Pratt, St. John's

Jelly Shelf, 1999
oil on canvas
55.9 x 71.1 cm
Collection of Equinox Gallery, Vancouver, British Columbia
Photography: Ned Pratt, St. John's

Pickled Baby Beets, 2000
oil on canvas
71.1 x 61.0 cm
Private collection

Raspberries Reflecting Summer, 2000
oil on canvas
61.0 x 91.4 cm
The Stonefields Collection

Jello on Silver Platter, 2001
oil on canvas
61.0 x 91.4 cm
Collection of Fox Harb'r Golf Resort & Spa

Specimen from Another Time, 2001
oil on canvas
55.9 x 71.1 cm
Collection of Louise Morwick
Photography: Sean Weaver, Toronto

Basting the Turkey, 2003
oil on canvas
40.6 x 43.2 cm
Collection of Michael and Inna O'Brian
Photography: Ned Pratt, St. John's

A Brighter Balance, 2004
oil on canvas
61.0 x 76.2 cm
Private collection

Threads of Scarlet, Pieces of Pomegranate, 2005
oil on canvas
91.4 x 61.0 cm
Private collection

Foiled in Gold, 2007
oil on canvas
50.8 x 76.2 cm
Private collection
Photography: Rachel Topham, Vancouver, British Columbia

Smears of Jam, Lights of Jelly, 2007
oil on canvas
40.6 x 50.8 cm
Collection of Equinox Gallery, Vancouver, British Columbia
Photography: Ned Pratt, St. John's

Brass, Glass, Peaches and Cream, 2008
oil on canvas
61.0 x 91.4 cm
Collection of Rob and Sandra May
Photography: Sean Weaver, Toronto

Between the Dark and the Daylight, 2011
oil on canvas
50.8 x 76.2 cm
Private collection
Photography: Rachel Topham, Vancouver

Acknowledgements

The Rooms Corporation acknowledges the generous support of the Government of Canada through the Department of Canadian Heritage Museums Assistance program; as well as the Canada Council of the Arts. It is also grateful for the continued support of the Government of Newfoundland and Labrador.

The Rooms Corporation of Newfoundland and Labrador, Provincial Art Gallery Division, acknowledges Sandy Newton (freelance writer/editor), Brenda Kielley (assistant to Mary Pratt) and Joan Ritchey, Jackie Hiller, Jane Deal and Krista Delaney at the Centre for Newfoundland Studies, QEII Library, Memorial University of Newfoundland, for research contributions to Mary Pratt's chronology and curriculum vitae.

The Art Gallery of Windsor is pleased to contribute an essay from its director, Catharine Mastin, to this publication. Mastin's essay research and writing has been generously supported with funds from the Social Sciences and Humanities Research Council of Canada and the University of Alberta, which granted the author several major doctoral fellowships and scholarships throughout the course of her doctoral studies.

 Canada Council
for the Arts Conseil des Arts
du Canada

Index

Contributors

RAY CRONIN is Director and CEO of the Art Gallery of Nova Scotia, Halifax, appointed in 2008. From 2001 to 2008 he was Curator of Contemporary Art at the AGNS. Cronin was the founding curator of the Sobey Art Award and served as chair of the Sobey jury until 2008. He currently serves on the Sobey Art Award Governance Committee. Prior to 2001 Ray Cronin was a writer, curator and artist based in Fredericton, New Brunswick.

MIREILLE EAGAN is Curator of Canadian Art at The Rooms, St. John's, a position she has held since January 2010. Prior to this, she was Curator at the Confederation Centre Art Gallery in Charlottetown, Prince Edward Island. Eagan has lectured nationally on Canadian art and has published several catalogues and essays on Canadian artists.

SARAH FILLMORE is Chief Curator of the Art Gallery of Nova Scotia, Halifax, and Curator of the Sobey Art Award. Fillmore has worked with the AGNS since 2005. In her role as Chief Curator she oversees the provincial art collection as well as the gallery's acquisition, interpretation, education, conservation and exhibition programs. She is curator of its artist-in-residence program and chairs the jury for the annual Sobey Art Award, Canada's pre-eminent prize for an artist forty or under.

CATHARINE MASTIN is Director of the Art Gallery of Windsor and Adjunct Associate Professor at the University of Windsor. She has held doctoral fellowships from the Social Sciences and Humanities Research Council of Canada and the University of Alberta.

SARAH MILROY is a Toronto writer and art critic. She served as editor and publisher of *Canadian Art* magazine (1991–96) and as art critic of the *Globe and Mail* (2001–10). Milroy has contributed to publications on the work of Gathie Falk, Jack Chambers, Greg Curnoe and Fred Herzog, and is a regular contributor to *Canadian Art*, *Border Crossings* and *The Walrus*.

CAROLINE STONE is Curator of Collections at The Rooms, St. John's, joining the gallery when it was established in 2003. For twenty years she worked in art exhibition and education roles for its predecessor, Memorial University of Newfoundland Art Gallery/Art Gallery of Newfoundland and Labrador.